ON THE BANKS
OF BAYOU CITY

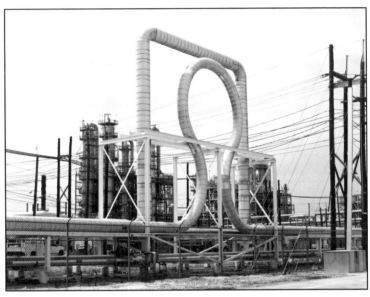

A pair of arched pipelines designed to help regulate product flow at the Rohm and Haas Deer Park chemical plant. This piece of land was once part of Dr. George Patrick's Deepwater Farm, a historically significant site that briefly served as the Texas Republic's seat of power immediately after the Battle of San Jacinto in 1836.

ON THE BANKS
OF BAYOU CITY

The Center for Land Use Interpretation
in Houston

Edited by Rachel Hooper and Nancy Zastudil

Blaffer Gallery,
the Art Museum of the University of Houston

Cynthia Woods Mitchell Center for the Arts
at the University of Houston

The Center for Land Use Interpretation's exhibition *Texas Oil: Landscape of an Industry* is organized by Rachel Hooper, Cynthia Woods Mitchell Curatorial Fellow at Blaffer Gallery, the Art Museum of the University of Houston. The exhibition and publication are presented in partnership with the University of Houston Cynthia Woods Mitchell Center for the Arts with additional generous support from Baker Hughes Foundation and Marita and J.B. Fairbanks. Additional in-kind support provided by PennWell MAPSearch.

blaffergallery
The Art Museum of the University of Houston

Blaffer Gallery, the Art Museum of the University of Houston
120 Fine Arts Building, Houston, Texas 77204-4018
www.blaffergallery.org

Cynthia Woods Mitchell
Center for the Arts

University of Houston, Cynthia Woods Mitchell Center for the Arts
209 CWM Center, Houston, Texas 77204-4016
www.mitchellcenterforarts.org

All interviews were conducted in summer 2008 unless otherwise noted.

Design: Design des Troy, San Francisco

Editor: Kathleen McLean

Distributor:
D.A.P./Distributed Art Publishers, Inc.
155 Sixth Avenue, 2nd Floor, New York, New York 10013
Tel: 212 627 1999
Fax: 212 627 9484
www.artbook.com

Library of Congress Cataloging-in-Publication Data

On the banks of Bayou City : the Center for Land Use Interpretation in Houston / edited by Rachel Hooper and Nancy Zastudil.
 p. cm.
Includes bibliographical references.
ISBN 978-0-941193-43-6
1. Center for Land Use Interpretation. 2. Landscape assessment. 3. Cultural landscapes--Texas--Houston Region. 4. Houston Region (Tex.)--Description and travel. I. Hooper, Rachel, 1980- II. Zastudil, Nancy, 1979- III. Blaffer Gallery.

F394.H82O6 2009
304.209764'141074--dc22
 2008049768

TABLE OF CONTENTS

INTRODUCTION

Working with the Center for Land Use Interpretation (CLUI) has been an exploratory journey that began more than two years ago during a conversation here at the University of Houston with John Reed, director of the University's School of Art. John was excited after speaking with CLUI director Matthew Coolidge, who expressed interest in Texas and, in particular, the Houston landscape, complete with its massive ship channel and bayou system.

Thus began a year-and-a-half-long partnership between our two centers that has included an extensive research residency, three university courses, establishment of a permanent field office in Houston, an exhibition, a series of major public events, and a collaborative project with fellow collective SIMPARCH, which will design and build a structure on Buffalo Bayou.

We at the University of Houston Cynthia Woods Mitchell Center for the Arts have hosted these activities with a range of partners. The Mitchell Center program was founded in late 2003 at the University of Houston in an effort to bring together the performing, visual, and literary arts by engaging in meaningful exchanges with visiting artists from around the world. The Mitchell Center's internal partners are the University's School of Art, Moores School of Music, and School of Theatre & Dance as well as its Creative Writing Program and Blaffer Gallery, the Art Museum of the University of Houston. While the Mitchell Center's official charge is to cultivate transdisciplinary exchange among art forms, we truly seek to work across the entire academy, collaborating frequently with the sciences, humanities, and other fields. So we consistently choose to work with visiting artists who challenge the way we view and understand boundaries of all kinds.

It is within this context that we invited the Center for Land Use Interpretation to Houston. Soon after our initial discussions with John, we brought into the fold two additional faculty members: Patrick Peters from the University's Gerald D. Hines College of Architecture, and Mat Johnson, a new member of our Creative Writing Program. Both are extraordinarily innovative practitioners and scholars, and they quickly became integral to the project. Together we discussed how we might create a program that fully supported the CLUI's interest in the region, while addressing the Mitchell Center's public engagement goals and encompassing University of Houston students. We wanted the CLUI to have a productive residency, which meant giving their members the freedom to roam Houston's landscape without being encumbered with the daily responsibility of teaching a course. At the same time, we wanted students to have consistent interactions with members of the group and to avoid the common problem that occurs with visiting artists: they come into a class for a brief flash of genius, but leave before they have the chance for any meaningful exchange with their audience.

After extensive talks with the CLUI, we invited the group for a residency. Three members were to alternate visits to Houston throughout the spring of 2008, and possibly through the summer to follow. Their focus would be Houston's Buffalo Bayou, a meandering waterway that encompasses the story of Houston's past as much as it crystallizes our present. Surrounded by lush foliage in the luxurious residential sections of the city, the bayou flows straight through downtown Houston and plunges into a highly industrial section of the city before arriving at the turning basin and, finally, the colossal Port of Houston Ship Channel.

The CLUI wanted to focus on this watershed and its role in the surrounding landscape, and for this it needed a research "outpost." We secured a trailer, and with the help of the Buffalo Bayou Partnership (BBP), the organization dedicated to restoring the waterway, were able to find a site that would become the CLUI's field office and, ultimately, a visitors' center.

You will hear more about the CLUI's residency from our project partners, so I will skip to what is coming up next. As I write, we are planning a three-pronged future that includes an exhibition by the CLUI entitled *Texas Oil: Landscape of an Industry*, which opens this January at Blaffer Gallery. This publication is a companion piece to the exhibition, telling the story of what's happened so far, and anticipating what's to come. Concurrent with the

exhibition and in collaboration with the BBP, we will offer public events throughout the winter and spring of 2009 that shed further light on the CLUI's extensive work in Houston. These events include tours of the bayou and ship channel as well as site-specific film screenings, lectures, and other surprises devised by the CLUI. Finally, we will unveil a newly commissioned work by design/build collective SIMPARCH, created in collaboration with the CLUI. Another of our collaborative projects with the BBP, the new work will be a custom-designed floating platform created for the bayou. Personally, I cannot wait to set foot on it and experience its maiden voyage across our city's bizarre and fascinating landscape.

There are a few parties to whom we hold an enormous debt of gratitude for making this incredibly multifaceted project a reality. Thank you to our exhibition host, Blaffer Gallery, the Art Museum of the University of Houston, and its incredible staff led by acting chief curator Claudia Schmuckli and acting director David Vollmer. And also, a huge thanks to Terrie Sultan, former Blaffer director, whom we miss enormously since her departure to the Parrish Art Museum in Long Island. Thank you to Patrick Peters and his scholarly home, the University of Houston Gerald D. Hines College of Architecture, led by the wonderful dean Joe Mashburn, and to the University of Houston Creative Writing Program, led by our dear friend and inspiration, j. Kastely.

This project would not have been possible without our collaborator, the Buffalo Bayou Partnership and its fearless leader, Anne Olson, who, along with visionary consultants Sandra Percival and Andrea Grover, found us a home for the CLUI and has hosted them graciously and generously. The BBP has worked with us more extensively than I could ever have imagined, becoming copresenters of the spring events and co-commissioners of the illustrious floating platform by SIMPARCH, which is only a spark of imagination as I write. And of course, thanks to Scott Barnes, who has been with us every step of the way.

And then there is the initiator — instigator, I should say — of this initiative: John Reed, to whom we owe this entire project; and another early participant, Bree Edwards, former Mitchell Center program manager and contributor to this book, who played a critical role in envisioning the two years that were ahead of us.

Finally, infinite thanks to Nancy Zastudil and Rachel Hooper for their tireless work on this catalogue as well as the entire CLUI project. I marvel at their energy, commitment, and intelligence.

The Cynthia Woods Mitchell Center for the Arts is named after one of the most visionary philanthropic souls on our planet, and I want to extend my most heartfelt gratitude to the entire Mitchell family. This project is inspired by the family's endless commitment to environmental sustainability and conservation, and everything we do is a testament to their generosity.

Karen L. Farber
Director
Cynthia Woods Mitchell Center for the Arts
University of Houston

EDITORS' ACKNOWLEDGMENTS

We would like to extend our deep appreciation to several key people who each played a role in the development and production of this book. First and foremost, we thank the members of the Center for Land Use Interpretation (CLUI), especially founder and director Matthew Coolidge, as well as Erik Knutzen, Steve Rowell, and Sarah Simons, who have consistently transcended categorization with their ambitious endeavors. Exemplary of the CLUI's educational mission, they have been extraordinarily generous with their time and talents. We hope that we have done their Houston project justice.

We are grateful to publication contributors Steve Badgett, Scott Barnes, Bree Edwards, Erin Elder, Mat Johnson, j. Kastely, Patrick Peters, John Reed, Steve Stelzer, and Katherine Veneman for their significant insights into land use and the CLUI's Houston residency. These vanguard thinkers fearlessly embraced complicated issues and offered new areas of inquiry about natural and human-made landscapes.

We owe a debt of gratitude to Karen Farber, director of the University of Houston Cynthia Woods Mitchell Center for the Arts, and Claudia Schmuckli, acting chief curator of Blaffer Gallery, the Art Museum of the University of Houston, for their guiding wisdom, trust, and support of this project.

This publication is both an epilogue to the CLUI's residency and a prelude to the exhibition *Texas Oil: Landscape of an Industry* at Blaffer Gallery. The support and cooperation of Blaffer Gallery staff members have been invaluable, and their humor and professionalism have kept us going even when the details seemed overwhelming. We thank David Vollmer, Karen Zicterman, Katy Lopez, Katherine Veneman, Measa Kuhlers, Mike Guidry, Kelly Bennett, Youngmin Chung, Karin Dickens, Susan Conaway, and Jeff Bowen. In addition, we would like to thank Blaffer Gallery interns Taylor Alvis, Caycee Carley, Christopher Conway, Elspeth Patient, and Suzanne Richards for their diligent work.

Baker Hughes Foundation and Marita and J.B. Fairbanks have provided crucial support for the exhibition. We are grateful also to PennWell MAPSearch for providing the maps in the exhibition. Special thanks also go to Green Mountain Energy, a company that has generously donated carbon offsets for the electricity that Blaffer Gallery will use during the run of the exhibition, and to Patrick Peters and his architecture students, who taught us the value of striving for carbon-neutral living.

We would also like to acknowledge Samantha and Owen Troy of Design des Troy in San Francisco for the beautiful book design; Paul Switzer and Bayside Printing Company, Inc., for their expertise and commitment to environmentally responsible production; Karina Abayian for careful interview transcription; and Kathleen McLean for her constant support and thorough work as editor. Steve Rowell's role as photo editor was also instrumental in the success of this book, and his beautiful photographs have captured the serene and often strange atmosphere of the area around Buffalo Bayou and the Houston Ship Channel. Geoff Winningham, professor of photography at Rice University, also deserves special thanks for his photographs of the bayou, which were taken before current restrictions on aerial surveillance. His enduring passion for the bayou is inspiring, and he has built an impressive archive of its beauty over the years.

We both came to Houston during the early stages of the CLUI's residency and have been fortunate enough to learn about our city from them—by walking through the landscape, taking boat tours on the bayou through the heart of downtown, and teetering on the margins of the natural environment and human interventions. The CLUI's curiosity is contagious and will continue to fuel explorations of Houston's peculiar environs. They have indeed made our world seem amazing, confusing, and astounding.

Rachel Hooper
Cynthia Woods Mitchell Curatorial Fellow
Blaffer Gallery, the Art Museum of the University of Houston

Nancy Zastudil
Program Manager
Cynthia Woods Mitchell Center for the Arts
University of Houston

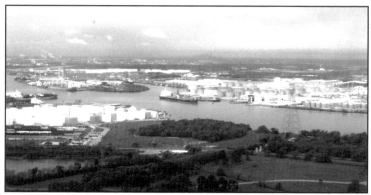

View of the Houston Ship Channel from the San Jacinto Monument.

AMIDST A PETROCHEMICAL WONDERLAND
POINTS OF VIEW ALONG THE HOUSTON SHIP CHANNEL

Originally published in the Center for Land Use Interpretation's newsletter The Lay of the Land, *Summer 2004*

A visit to the Houston Ship Channel is a compelling activity, highly recommended for anyone interested in current events. Here, in this petrochemical Mecca, the largest petrochemical complex in the United States, the full extent of our saturation in the oil economy can be seen, felt, smelled, and fathomed. From Houston, a tour can easily be done in a day, and there are numerous interpretive areas, monuments, markers, and museums that help visitors understand this most complex complex.

The ship channel is an expanded version of an old muddy creek called the Buffalo Bayou, which connects downtown Houston to Galveston Bay and the Gulf of Mexico. It was enlarged for shipping in stages over the past two centuries, initially to bring Southern cotton to the coast. It wasn't until the U.S. Congress officially declared Houston, fifty miles inland, a Port City in 1870 that the dredging and widening projects really took off. With the work of the Army Corps of Engineers and the resources of investor Charles Morgan, a shipping magnate eager to avoid Galveston's dockage fees, the first oceangoing vessel made it up the channel in 1876 (an event that no doubt rivaled the local celebration of the nation's centennial in importance that year).

The Port of Houston, which manages many of the ship channel's terminal facilities and includes the petrochemical plants of the area in its figures, is one of the busiest ports in the country, handling more foreign tonnage than any other, primarily in the form of bulk materials, and most of it petrochemical. Texas refines more oil than any place in the United States and much of that refining capacity is located along the ship channel at more than twenty petrochemical plants in the channel area. They are linked by pipelines, selling streams of liquid product to one another, and bringing in crude from hundreds of platforms in the Gulf as well as heavier, cheaper crude from Mexico.

Some of this superlative industrial land and seascape can be viewed on the Port of Houston's free public boat tour aboard the *M/V Sam Houston*. The ninety-minute tour leaves from the port's Sam Houston Pavilion and accommodates up to one hundred people. It is often crowded with schoolkids. The tour covers the turning basin area, the most inland portion of the navigable ship channel, and passes the Highway 610 bridge. A few petrochemical plants are visible along the way, but the most impressive sights may be a large U.S. Gypsum shed full of Mexican gypsum, the old Deepwater Power Plant, and the massive Public Grain Elevator #2. The boat turns around soon after passing the first major refinery on the ship channel, the Lyondell Refinery, a medium-sized plant that processes heavy crude. With a capacity of around 270,000 barrels per day, it is the fourth largest in the ship channel area, and the eleventh-largest refinery in the nation.

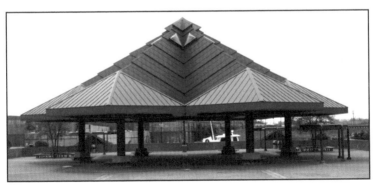

Futuristic canopy at the Sam Houston Pavilion, where the *M/V Sam Houston* takes visitors on the Sam Houston Ship Channel. "Houston," of course, was the first word uttered on the moon by astronauts speaking with the Johnson Space Center, also located in the ship channel area.

Up the creek on what used to be Buffalo Bayou, on the Port of Houston's tour of the ship channel.

To get into the heart of the ship channel's petrochemical countryside, land is the preferred route, and there are several spectacular viewing opportunities and interpretive facilities provided by the state historical and transportation agencies. From the 610 loop, south of the channel, head east on La Porte Freeway (Highway 225) through the town of Pasadena, where you can see the Crown Central Petroleum Corporation's refinery (one of two in the country owned by this small, independent oil company) off Shaver Street, and numerous industrial parks and pipeline facilities, until you reach the monumental Shell Deer Park facility. Shell Deer Park is a 1,500-acre complex composed of an oil refinery and a chemical plant. The refinery employs around a thousand people, and is the sixth largest in the nation, with a capacity of 340,000 barrels per day. The refinery is half owned by Pemex, the Mexican state oil company, and approximately 70 percent of the crude processed at the refinery is Maya and Olmeca crude oil imported from Mexico. The balance is domestic crude oil, mostly from Texas and Louisiana. The chemical plant employs eight hundred people and is a major national supplier of base chemicals for plastics, paints, and other products. North off the 225 on Route 134, visitors will pass the Rohm and Haas Deer Park Chemical Plant, which makes acrylic adhesives, plastics, and paint. This is the way to the finest viewing site in the ship channel area: the San Jacinto Monument.

This state historic monument is an Art Deco obelisk that is the tallest freestanding memorial column in the world. It is located on the San Jacinto battlegrounds, which now happen to be on the edge of the ship channel.

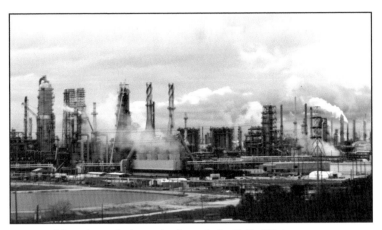
ExxonMobil Baytown: the largest refinery in the United States.

Built in 1939, it is five hundred seventy feet tall (fifteen feet higher than the Washington Monument, due to a large Texas star at its top). It has an elevator that takes visitors to an observation deck that features a dramatic 360-degree view, albeit through fairly small windows, of the low flat land of eastern Texas.

Visible to the east of the monument, further down the ship channel, is the largest oil refinery in the country, ExxonMobil's Baytown complex. Of the one hundred fifty or so oil refineries in the United States, the average processing capacity is less than 150,000 barrels of crude oil per day. The Baytown refinery's capacity is 525,000 barrels per day. In addition, the plant has two research centers and two chemical production facilities that make plastics such as polypropylene and synthetic rubber, and specialty fluids for paint and household cleaners. It employs nearly six thousand people.

After Baytown, the ship channel passes DuPont's La Porte plant, which since the mid-1950s has been making weed killers, formaldehyde, and other biochemicals, and is the world's largest manufacturer of polyvinyl alcohol, which is used in the clothing industry for weaving polyester blends into synthetic fabrics such as Lycra and Spandex, and for acetates that are used in things such as car windshields. The plant employs around a thousand people.

Highway 225 ends at DuPont, at the intersection of Highway 146, where a great view can be had off the Fred Hartman Bridge, whose eight lanes of

roadway soar over the ship channel. The bridge is the largest cable-stayed span in the country (though the Dames Point Bridge in Jacksonville, Florida, is fifty feet longer, it is not as wide as this one). It opened in 1995, replacing the narrow Baytown Tunnel, which was constructed fifty years ago and had become an obstruction to the effort to deepen the ship channel to accommodate larger ships. After the bridge opened, the middle section of the tubular tunnel was removed by flotation and barged to the Gulf, where it was sunk, joining numerous sunken oil rigs as an "artificial reef." The two end sections of the tunnel, closer to the shore, were flooded and left in place.

At this point, the ship channel now flows in a dredged channel of the San Jacinto River, Buffalo Bayou having drained into San Jacinto Bay near the monument. The river winds through a series of small islands and bays, rounds Morgan's Point, with the Port of Houston's large container facility at Barbours Cut, then spills into Galveston Bay. The oil industry picks up again dramatically at Texas City, and Highway 146 takes you there.

Texas City has three refineries: Valero, which is mid- to large size at 215,000 barrels-per-day capacity; Marathon Ashland Petroleum LLC, a joint venture between Marathon Oil Corp. and Ashland Inc., which operates a smallish refinery with a 76,000 barrels-per-day capacity; and British Petroleum (BP),

Amid the very same refineries damaged by the Texas City explosion of 1947 is a commemorative marker and the propeller from the *SS Highflyer*, an ammonium nitrate–filled ship that exploded sixteen hours after being set ablaze by the explosion of the *SS Grandcamp* in the Port of Texas City.

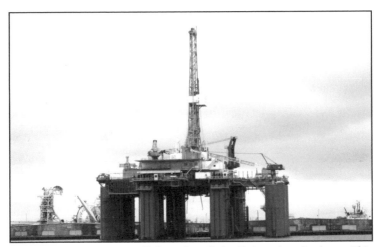

The Galveston Channel usually has a few oil rigs tied up along its shores. This one was used as a film location for the movie *Armageddon*.

which has its largest refinery here with a capacity of more than 450,000 barrels per day, making it the third largest in the nation.

Across from the Valero and Marathon refineries at the entrance to the port of Texas City is one of two monuments that discuss the thing Texas City is most famous for: blowing up. In 1947, a French ship filled with ammonium nitrate (which had been converted from explosives to fertilizer at chemical plants in the area for shipment to Europe) caught fire in the harbor and soon exploded. The shock waves from the explosion damaged the industrial plants and refineries in the region, many of which, since they deal with extremely volatile material, also caught fire and had their own cascading series of explosions that lasted for days. Fifteen-foot waves generated by the explosion washed through town, and later that night, another ammonium nitrate ship in the harbor, which had been on fire all day, exploded, sending the worst of the shock waves across the ruined city. It took a week to put out all the fires. One-third of the homes in the town of sixteen thousand were condemned. A total of nearly six hundred people were killed.

The main memorial for the disaster is located at the cemetery, just east of Highway 146, on the north side of Loop 197. Continue down Loop 197 through town to the refineries and the port on the south side of town, then back onto Highway 146, and then to Interstate 45, the Gulf Freeway, which

leads to the last interpretive site on this remarkable chain of petrochemical production, the *Ocean Star* Offshore Drilling Rig and Museum.

The refineries of the ship channel are referred to by the oil industry as the "downstream" end of the industry, where the raw material is processed into saleable products. As we flow downstream on the ship channel, we get to the "upstream" end of the industry, at Galveston and the adjacent Gulf of Mexico, where the crude oil is extracted from the earth. The Galveston Channel, the sheltered inland side of the island, is littered with oil rigs towed in from the Gulf for repair or scrap. Some are used for parts, some are reconditioned, and some seem to remain for use as movie locations. One has been turned into the *Ocean Star* Offshore Drilling Rig and Museum, a most remarkable and unique museum about this startlingly complex and dramatic part of the petrochemical industry.

After a visit to the *Ocean Star*, visitors to the petrochemical corridor around the Houston Ship Channel will have completed their immersion into the land of oil. The return trip to Houston via Interstate 45 takes only an hour. Back in Houston, a tour of oil, oil services, and energy company headquarters shows another aspect of the industry. But that will have to wait for another day.

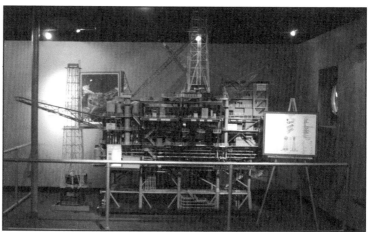

One of dozens of impressive displays, models, and artifacts at the *Ocean Star* Offshore Drilling Rig and Museum.

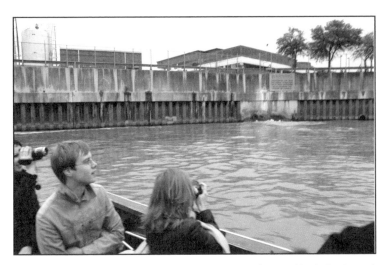

Field trips along Buffalo Bayou in the CLUI research vessel include stops at Houston's main sewer outfall, where visitors confront the notion that the treated water entering the bayou might make this the cleanest part of the waterway.

CLUI OPENS FIELD OFFICE IN HOUSTON
GULF STATES LOGISTICS SITE SUPPORTS PROGRAMS IN REGION

Originally published in the Center for Land Use Interpretation's newsletter The Lay of the Land, *Winter 2008*

The CLUI Field Office in Houston was opened in January 2008 to support an expanding roster of programs in the region. Located at a former junkyard on the industrial fringe of the east side of the city, the site also has frontage on Buffalo Bayou, the main shipping channel and drainage artery for the City of Houston. "This is a most appropriate and advantageous location for the series of present and upcoming CLUI programs in the area," said program manager Matthew Coolidge. "We are grateful to all the individuals and institutions that made this possible."

The field office was established with the support of the Cynthia Woods Mitchell Center for the Arts at the University of Houston, and the Buffalo Bayou Partnership, an organization that is helping to bring people back to the city's urban waterfront.

The initial purpose of this facility, a logistics site for the Los Angeles–based CLUI, is to serve the educational community of the University of Houston over the spring semester of 2008—specifically the departments of Art, Creative Writing, and Architecture—to assist with the development of creative interpretive projects in the region. A series of field trips conducted by members of the CLUI with students from the University are based on three themes related to the physical and economic landscape of the city.

One theme is water, specifically drainage. The city of Houston was founded at the confluence of the White Oak and Buffalo bayous at a spot known as Allen's Landing, named for the Allen brothers who landed there and platted out the early city in 1836. Buffalo Bayou, which drains into San Jacinto Bay and the ocean beyond, was later dredged and widened to accommodate shipping into the city's core and became the central artery for its developing economy, supported by rail and then highways. The downstream portions of the bayou evolved into the ship channel, the industrial Port of Houston, one of the busiest in the nation and the heart of the nation's petrochemical industry. The waterway is the industrial city's front door.

Conversely, the bayou is an essential egress. The city, built on flat and swampy grounds in a region prone to heavy rains, is dependent on the historic bayou network to get stormwater out of the city as quickly as possible. The bayous (White Oak, Brays, Sims, and the upper Buffalo) have been channelized and reinforced to accommodate this task. Portions of Buffalo Bayou have been spared from this invasive engineering and, especially on the portion between the ship channel and downtown, remain a chaotic and beguiling incidental landscape, cutting through the core of the nation's fourth-largest city.

Another theme being explored in collaboration with students from the University of Houston is that of bulk materials. The bayou is a corridor for aggregate, which is transported by barge to construction projects around the city. These materials—sand, gravel, crushed rock, concrete—form the literal building blocks of the city. Where it comes from and how it is used is being studied by the students, led by Erik Knutzen of the CLUI (who was project manager for *Ground Up* at the CLUI in 2003, an exhibition and tour program that examined the aggregate industry in Los Angeles).

The third theme being addressed with the students by Native Houstonian Steve Rowell of the CLUI is the oil industry, which of course is the raison

d'être for the modern city of Houston. The field office also serves as a regional base for the CLUI, supporting the development of other public programming in the Houston area, including future tours, exhibitions, and events based out of the field office location and at other venues in the city. These programs also relate to Buffalo Bayou and the industrial waterways of the city, and to the oil industry that is concentrated in the Houston region. A CLUI exhibition about oil will be on view at the Blaffer Gallery at the University of Houston in January 2009.

The CLUI Houston Field Office and Gulf States Logistics Site follows the model established by the CLUI in a number of other locations, including the Mojave Desert Research Station and Information Center near Barstow, California; the Great Basin Landscape Information Center and Residence Program in Wendover, Utah; and the Northeast Regional Office and Information Center in Troy, New York.

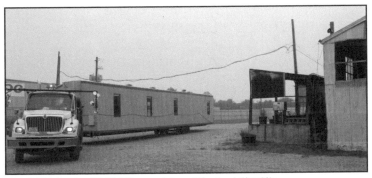

The CLUI Houston Field Office arriving at the Logistics Site.

The Logistics Site is a former junkyard on Buffalo Bayou across from J.L. Proler Iron & Steel Company, a major regional metal scrap yard.

The CLUI Field Office in Houston.

ON RESIDENCE, IN PLACE
MATTHEW COOLIDGE
IN CONVERSATION WITH
BREE EDWARDS

Matthew Coolidge is the founder and director of the Center for Land Use Interpretation and serves as a project director, photographer, and curator for its exhibitions. He has written several books published by the CLUI, including *Back to the Bay: An Examination of the Shoreline of the San Francisco Bay Region* (2001) and *The Nevada Test Site: A Guide to America's Nuclear Proving Ground* (1996). He lectures widely in the United States and Europe on contemporary landscape matters and is a faculty member in the Curatorial Practice Program at the California College of the Arts, where he teaches the class "Nowhere."

Bree Edwards is an independent curator and cultural producer who has held the positions of program manager at the University of Houston Cynthia Woods Mitchell Center for the Arts and curator of public programs at the Asheville Museum of Art, North Carolina. Edwards studied urban archaeology and the history of utopian thought at the Institute for Social Ecology, Goddard College, Vermont. She completed her MA at the Center for Curatorial Studies at Bard College, New York, followed by a postgraduate curatorial fellowship at DeAppel Center for Contemporary Art, Amsterdam.

BREE EDWARDS: Let's start with the origins of the CLUI. In the early 1990s you were working in the Bay Area of Northern California. What were some of the first projects you did in a museum context?

MATTHEW COOLIDGE: The first thing we did was to construct a museum context around everything we did. And by museum I mean an institutional, museological approach, in the same way the Smithsonian engages in research by archiving, curatorship, field research and science, astronomy, archaeology—they do pretty much everything, and it is all wrapped in museumness. That seemed like the thing to do, and this was the first step.

Once this was established, by filing papers with the government, getting a logo, a letterhead, mission statement—essentially committing to the idea that this is what we are going to do, forever—it has meaning,

utility, service, and even urgency. Once the decision was made to *do this*, everything followed naturally. The first exhibition we did was called *Denaturalized Sites*, and it depicted beguiling altered landscapes, scenes where clear or enigmatic, transformative events had occurred. It was very general in theme, but specific in its photographic style, in what it depicted. It was sort of microcosmic, detail-oriented. Looking back, I think it was partially an exercise in zeroing in on a standardized, institutional photographic methodology and trying to understand the relationship between an image and its text caption.

BE: What artists were you interested in at that time?

MC: Personally? Artists of the 1970s who dealt with place and land, like Robert Smithson, Nancy Holt, Michael Heizer, Mary Miss, Alice Aycock, James Turrell, Alan Sonfist, and Dennis Oppenheim. Bernd and Hilla Becher were important, of course, and their progeny, like the German photographers Andreas Gursky and Thomas Ruff; and American New Topographics photographers influenced by the Bechers such as Lewis Baltz, Richard Misrach, Peter Goin, Mark Klett; iconoclasts like Jeff Wall, early Bill Viola video, Allan Sekula, James Benning. Other Düsseldorfers, of course, like Joseph Beuys, and other '70s conceptualists like Douglas Huebler, Michael Asher, Chris Burden, Bas Jan Ader, William Wegman, N.E. Thing Co. Ltd., Lawrence Weiner, Allan Kaprow, Ant Farm, though the prankstery stuff seems less interesting now somehow, certainly entertaining, but of less sustaining, enduring substance. As you get older, I think you begin to appreciate people who don't just tear things apart, but who put things together, too. Criticism is easy. Believing in something is hard.

BE: Were there other main influences?

MC: Hard to say, as we weren't really trying to be like anything, but instead I suppose unlike a lot of things, but nothing specific. Except maybe the Smithsonian—both like and unlike it. We had no heroes. But there were people and precedents that I found inspiring, because they weren't afraid to take risks, like Werner Herzog, the Museum of Jurassic Technology, and John Wesley Powell, for example. Writers too, like J. G. Ballard, William Gibson, Stewart Brand and all that

Whole Earth–type stuff from the '70s. And later discovering people like J. B. Jackson and the landscapists associated with him, like John Stilgoe and Paul Groth, helped us feel that we were on some kind of track, mining a vein that was of value.

BE: In early 2008 you came to Houston for the residency with the Cynthia Woods Mitchell Center for the Arts at the University of Houston. What was that like?

MC: The residency gave us an opportunity to get to know the city and to work with students, many of whom helped us to learn about the city, too. We installed an office trailer to serve as a base, or field station, and as a point of origin for forays into the landscape or the waterscape. It is important for us to create distinct contexts. Even if we are associated with a school, we want it to be clear that this is something different, not part of the usual academic programming. The students would go there to meet during class time, and we would go out into the landscape from there, either overland or by boat. So the field station serves as kind of portal, and a reorientation facility.

The location is perfect—a former junkyard on the Buffalo Bayou where garbage is now pulled out of the bayou, and directly across from a metal scrap yard. Being there, especially in the evening, the

The CLUI Houston site, a former junkyard on Buffalo Bayou.

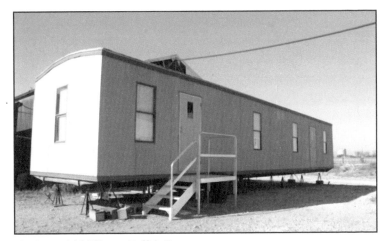
The CLUI Field Office on Buffalo Bayou.

place is transcendent. The complex sounds of the scrap yard become like an orchestra of disintegration, the collision of metals, the grinding, the cascading, and the crushing, and visually the place is epic: sparks flying from the scrap yard, the sodium lamps from the gasket and valve factory next door flooding the place, buzzing, the office lights of the KBR complex twinkling, and Houston's dramatic, Emerald City–like downtown skyline in the distance. It's a compelling location.

BE: What makes Houston's waterfront a unique site?

MC: It's both unique and typical. It's unique in that it is superlative; it is the main drain for this big important American city. It includes the Houston Ship Channel, with all of its industry, especially its connections to the petrochemical industry that are centered here more than anywhere else in the county, and maybe the world. On the other hand, it is just a muddy urban backspace, an incidental back door into the urbanscape, a cross section. It's also as a forgotten space very interesting, kind of mysterious. Other than the very occasional canoeist or kayaker and barge there is literally no traffic on the bayou above the ship channel, up to downtown, because the public is cut off downstream from getting into the upper bayou by the security of the ship channel, and there are no public boat ramps on the upper bayou. Being in a boat feels like being in the city in some other time, like an anthropological landing party approaching a new culture from the river, like Joseph Conrad, and *Apocalypse Now.*

BE: Over time, the CLUI has been the guest of various art departments and schools of architecture. And you also host your own artist-residency programs on a decommissioned military base on the edge of the Great Salt Flats in Wendover, Utah. Based on these experiences, what would you say are the key factors in having a successful residency?

MC: If ours is successful, then I suppose it's about being fair, reasonable, and open-minded, but also about selecting people who share the ideals and principals of community and understand that they make it what it is. They are all collaborators—they are compelled, but not expected, to leave it better off than they found it. But we don't want to force community on people; we let them roam and wander, relate to the others in the residency how they want. We keep the emphasis on the place, too, which is really why they are there, and let them explore it and relate to it on their own terms. We don't have the resources to coddle people, so we are careful to avoid those who seem like they expect that. We try to make that clear in our information about the place, so most who are looking for an easy ride look elsewhere.

BE: What is the CLUI's attraction to the mobile office trailer all about?

MC: Now *that's* a good question. I think they represent the state-of-the-art modernist assembly-line buildings that people from Le Corbusier to Jennifer Siegal have been seeking to have in the world, but seem not to be able to figure out yet. Office trailers are staring us in the face. They are buildings. They work. They have air-conditioning, windows, and doors. You can connect them, make a complex. They can be moved, so you're not stuck in one place. Conceptually, they have many things going for them too, like their association with site work, like a construction trailer. They are temporary, transient—what isn't? They tread lightly on the land, not needing foundations, drainage. They are utilitarian, providing just what you need, but no more. Form following function, for sure. They are modular—structured in units of four feet—so it's easy to replace panels outside or inside. And they are modifiable and customizable, if you need to, just like a house, sixteen inches on center two-by-four-foot wood stud walls, two-by-six-foot floor and ceiling joists, standard commercial drop ceilings. And you can get them for anywhere from free to $20,000—for more than seven hundred square feet for a twelve-by-

sixty-foot. That's economical. So anyway, seems they have everything going for them, including formaldehyde and industrial adhesives. But millions of people live or go to school or prison in trailers with the same problem. Modernity is at least slightly toxic.

BE: You often use boats and planes for research and documentary purposes. How does leaving dry land influence one's experience of the landscape (especially in this case, where you've utilized a boat to conduct tours of Houston's environs)?

MC: We try to provide fresh perspectives on familiar space, and sometimes that is best done literally by providing a view from an atypical point of view. Not that aerial images aren't common, but aerial images of some things are not very common at all. And the boat allows you to transect through a space obliquely—from what is often the back door, the drainage corridor, the industrial waterfront—providing a new view of a city or region.

BE: I have experienced firsthand the total sincerity with which CLUI members play the role of tour guide when leading field trips and guided tours. But with all guides or teachers, there is a performative aspect in leading others through an experience and assuming the role of expert. Can you talk about how this format developed?

MC: We like to think the tours are somewhat like a typical tourist bus tour, at least at the start. If it was weird from the get-go, people would be too uneasy. So we have to appear initially like we know what we're doing, and that we have it all planned out, and there is bottled water and a bathroom and a lunch break and so on. In fact, we do have things planned out, usually down to a five-minute margin, and have scoped the route numerous times, and have every turn and vista mapped out. For example, what video clip we show at what precise time, what local briefer is expecting us, and all the segues between things. To me, as I am often the tour guide, I feel like I am doing a performance, like you say. Maybe even stand-up comedy, even if I am not being funny. Thinking about the timing of the spiel, setting things up, the silences, building anticipation, delivering the next site as a punch line—it's like narrating in multimedia space. It feels theatrical, and the theater is moving in space as well as time.

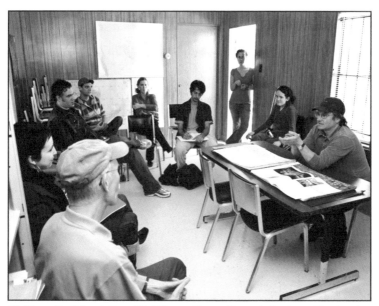

Matthew Coolidge talks with UH creative writing students and instructor Mat Johnson.

I am holding a mic in the front of the bus. What it's like as this disembodied voice yammers on over the speakers in the back of the bus is something different. It becomes maybe a bit more like an interpretive ambient after awhile. I hope the tours also appear to disintegrate, in a way, to become less than perfect, a bit explorative, like a collective research expedition. We usually push the limits of where a bus can go, down iffy dirt roads, on levees or dams and such, where we don't completely know the outcome. We are in the same boat, a bit *Gilligan's Island*-esque. Keeps it exciting. We also want the tours to melt into over-stimulation, so that by the end of a ten- or twelve-hour day and a four-hundred-mile ride, people shut down, feel exhausted, and have to stagger back to reality after we get back. If it's too comfortable, it's not going to sink deep. Momentum is built up. The tour keeps going as people recollect and reconstruct it in their minds after the fact. Like they eat a big meal, and then let it digest.

BE: What is the crucial thing about being on-site? I mean, how does direct experience with the landscape alter the experience for the participant, who is also audience? And also for the interpreter, who in many cases is an artist or expert?

CLUI boat tour of Buffalo Bayou with UH students.

MC: If the CLUI is like a museum, or *is* a museum, even, then the material artifacts we deal with are places. You cannot put them in a gallery, as they are too big, and even if you could, doing so would be to pull them out of their context, which would change them completely, as all places are connected to their surroundings. So instead, we have to take people to the places, the artifacts under consideration, if we can. That's why we like the bus tours—they are like curatorial odysseys. Since you can't put the place/artifacts in a vitrine, you take the vitrine to them.

BE: How is this experience in the landscape with CLUI different from seeing one of your exhibitions in the gallery of the museum?

MC: A CLUI exhibition is a version of things, not the thing, so it's more about interpretation than land use. Granted, it is just one generation removed from the place: we ground-truth everything, we go there, and we talk to people. We show photographs in the exhibitions that we took at the site, not stock photos from a second party. So in our exhibitions you are getting just a single layer of interpretation, the layer we provide, which for better or for worse is as distinct, as impartial, and as fresh as we can make it be. But when you go there, either on your own or with a bus tour, you experience the place

directly, and that is always a good thing. Once you have been somewhere, you remember it so much more. The material artifact analogy: if you see a photograph of a stone tool, say, it looks real, but it is just a representation in two dimensions. If you see an actual ancient artifact in a case, it's better, you are in its presence, you relate to it in 3-D. If you can pick it up and feel it, even better still—it is tangible. And if you can go to where it came from and even pull it out of the ground, become immersed in the environment, breathe it, get dust from it in your clothes, or whatever—*that's* memorable, lasting, and potentially transformative.

BE: What impact do you hope the CLUI's residency will have on the University of Houston? Houston as a whole?

MC: We don't know how things will go, as there is much to be done, and what we plan on doing will evolve into what we actually do in ways we can't anticipate. But the city is increasingly exotic the more time we spend there, and hopefully we've been able to convey a sense of the bizarre ordinariness of this city. Houston is more American then America itself, it seems. It really is one of the most surprising— shocking, really—places on earth. And in our own small way, we hope to leave the place better off than we found it.

John Reed on the Wendover Salt Flats, pondering the curvature of the earth.

A DIFFERENT KIND OF SPLENDOR
JOHN REED
IN CONVERSATION WITH
KATHERINE VENEMAN

John Reed is a multidisciplinary artist who utilizes a broad background of engineering and technical training to respond to perceived needs in society. His work often takes the form of various systems, whether as a quixotic machine, a website, an installation, or an earthwork. Since fall 2006, he has been director of the University of Houston School of Art, and prior to his arrival in Texas, he was technical director of sculpture at the California Institute of the Arts. Previously, he made prototypes for an aerospace company in San Diego. He received his MFA from the University of California, San Diego.

Katherine Veneman is curator of education at Blaffer Gallery, the Art Museum of the University of Houston. Her innovative educational program, Art Focus, centers on mentorship and collaboration and recently received an award from the Institute for Museum and Library Sciences. Before moving to Houston in 2004, she was director of Hera Gallery/Hera Educational Foundation in Wakefield, Rhode Island. She is a practicing painter and has exhibited her work throughout the United States.

KATHERINE VENEMAN: So John, you developed and taught an art class at the University of Houston called "Other Terrains," and your students worked with the Center for Land Use Interpretation during the spring 2008 semester?

JOHN REED: Yes, "Other Terrains" was a small class with only seven students, and after meeting members from the CLUI, some of those students decided to work collaboratively.

KV: And how did you first encounter the CLUI?

JR: Well, I was a graduate student at the University of California, San Diego. Igor Vamos of The Yes Men was one of the graduate students who was there before I was and was someone I looked up to.

We had a sort of collision of opportunities. It started off with Igor, Matt Coolidge, and me taking a twelve-hour drive in a Cadillac convertible from San Diego to Wendover. Matt, whom I did not know at the time, knew Igor, and Igor knew Matt's work. Igor wanted to buy his brother a Cadillac, but he wanted to test-drive it first. Matt wanted to scout a location in Wendover, Utah, for this residency idea he had. Wendover, by the way, is on the border between Utah and Nevada, at the western edge of the Bonneville Salt Flats. It's home to what was once the largest military base in the world—now decommissioned, or mostly decommissioned. It's an other-worldly place. Later, I would understand how good Matt is at picking places for their sublime qualities.

And, as disastrous as that trip was with, you know, getting the Cadillac stuck on the salt flats, then losing it, and a whole series of calamities, we did actually end up making arrangements to rent army barracks. At that time, I believe the city and the airport jointly controlled the demilitarized architecture there. So that was my introduction to the CLUI.

Some months later, I went up to Wendover for a work party to help renovate the space for the artist-residency program and ended up being their first artist-in-residence. The nature of the residency that the CLUI had conceived was different from others. Wendover has semi-repaired army barracks on the edge of the most uninhabitable, unfriendly landscape you can imagine with the residues of all these giant military and industrial projects just abandoned in such large scale.

Since I had not gone to graduate school as a particularly advanced thinker about art, I was still at the point where I was opening my mind to this sort of thing, and it was eye-opening for me. It was difficult, and I kept thinking, "This is insane." We weren't focused on making art as much as doing something that was fundamentally interesting— something that was a blast to do, probably like the kind of thing that inspired the first people to go do Burning Man. It appealed to all those desires that relate to, say, taking a road trip to the middle of nowhere.

KV: What type of work were you doing at the time? I read that you made a contraption that could go out on its own and etch or slice the salt to produce a drawing of sorts. Am I describing that correctly?

UH art student Nick Teel's final project for "Other Terrains" installed at Lawndale Art Center, Houston.

JR: The idea really was that my artworks would take on a life of their own. I thought it'd be funny to make the largest drawing on earth, right? But then the first thing I thought was, "Well, *I'm* not going to make it, because that would be a lot of work, so I'll get something else to make it." Now, it would be a lot easier to program a machine and tell it what to do. Go a hundred feet, make a right, go another hundred feet, make a left, go fifty feet, make a left, you know? That would be easy. But I wanted to make each one of them very carefully so that their direction would be not random but unpredictable, because it would be based on environmental conditions, which were unpredictable.

So, "Ha, I'm the author of the biggest drawing on earth!" But actually, the machines are making the biggest drawing on earth, except it's eroding as fast as they're drawing it, because it's on a salt flat. And indeed, the machines were eroding as fast as they were drawing, too. They were programmed to interpret environmental conditions, and the output gets mapped onto the salt flats. One of them looks sort of like an EKG printout—and that's really done as a reference so that people look at it and try to figure it out. But the overall idea was one where observers wouldn't ever be able to arrive at an exact conclusion as to what the drawing is.

My original idea was that I would build these machines so well that they would outlast me, so they would be going on drawing and doing their thing long after I had bought the farm. But the reality is that the salt flats are a harsh place.

KV: The way you describe the residency and your project makes them both sound like some sort of survivalist adventure.

JR: Exactly, a survivalist adventure. And I have to be honest—in a weird way it has this different kind of splendor. So that's how I got involved with the CLUI, and I've tried as much as possible to be a supporter ever since. I think it's a remarkable organization. The members are generous, both to the people who are involved with them and to their audience. They let people think for themselves, and they've caught hell for that, too. I can't quite remember all the details now, but I remember some publication criticizing them for being too apolitical, which I felt was so crazy. I like the fact that the CLUI lets people think for themselves by presenting the facts—even if it does it with a little bit of a smile.

John Reed constructs a machine that will etch the world's largest drawing on the Wendover salt flats.

KV: The CLUI's process is simple but interesting—a process of inquiry using steps that they apply to a particular place or order to come up with something original.

JR: Yes, maybe a quasi-scientific or quasi-journalistic approach, but definitely in a good sense. It all seems very dry, but I think the results are actually very rich. So that's one of the main reasons why I think it's a fantastic organization.

KV: So let's fast-forward. Why get the CLUI to come to Houston, to the University?

JR: I felt that the CLUI would be a great introduction to and a perfect catalyst for getting the School of Art to expand, applying a form of active research to the actual doing and making of things and projects. I figured that the College of Architecture would be interested, since they are always interested in that sort of thing. They're so nondisciplinary that they're interdisciplinary. Also, I felt the Creative Writing Program would benefit from and love it, too. And every time the CLUI does a project, there ends up being a lot more interaction than you originally guess there's going to be. Often, you invite

someone hoping that it will be an interactive experience, and it falls short. With the CLUI, it's kind of the other way around—all kinds of stuff starts going on that you didn't plan for.

KV: From what I saw, each of your students' projects seemed to take on a more and more intimate direction of its own and kept moving forward. I don't know how you felt teaching the class, but just seeing how the members of the CLUI were interacting with the students, as projects on both sides started to evolve, it seemed that they learned a little bit from each other. Do you agree?

JR: You know, it's hard to say from the outside, because I would venture to say that the students were in a position this past semester similar to mine upon meeting members of the CLUI several years ago. Honestly, I don't think the students knew what to make of everything.

KV: Let's talk about some of the goals for your class. How did you set them and then what happened?

UH art students Evangeline Royer and Sylvia Sykula's final project for "Other Terrains" hangs in a window at Lawndale Art Center, Houston.

JR: Well, we didn't want the class to just be about the CLUI. My understanding was that the CLUI members didn't want to teach a class but instead wanted to be able to focus on their research, and then present that research to students.

The idea of "Other Terrains" was primarily about mapping as a way of thinking about art-making or as an alternative way of art-making. The mapping process itself is this: you look at something, you decide what qualities you're going to pay attention to, you find a way of collecting that information or plotting it and somehow making sense of it, then you analyze it, and then you present it. And in a weird way, mapping gives the students a method for art-making that has steps similar to those involved with formal research.

So we viewed the CLUI, more or less, as a kind of inspiration, but it's not solely devoted to mapping anymore than I am. The idea was really that we would go out and interact with the CLUI's research. And, mostly for the purpose of inspiration, we talked about how the CLUI operated—for example, how it gathered data. And we would just talk about my students' interests in the class. Now, that said, I brought in some kind of curious examples of mapping so that they could understand that I'm not talking about just making maps.

KV: I'm familiar with mapping as a way of mediating between experience and an object, or a landscape, or a body. It's a way of connecting the experience with its physical forms—taking attributes of one thing and ascribing them to another, with the map itself as the mediation device between the two so you have two sources. But, as an artist, you're not going to be able to do everything, right? You don't want to.

JR: Actually, I think that's the good part. The good part about the mapping process is that you have to admit to what it is you're doing in the first place. Looking at anything is interpretive anyway. You look at something and you choose to pay attention to this or that, maybe without even noticing, and mapping just verifies that in your own mind. It's like, "OK, this is what I'm doing, I'm looking at this large process or this area or these series of events or this news or whatever, and I'm picking out things perhaps thematically, or I'm choosing to pay attention in some kind of subset." Then I collect the data about that subset. I analyze it, and I find a way to present it. It's a very loose

way to look at mapping. If you think of "mapping" in the traditional sense, you always think of a map.

KV: So how subjective is that process? Why did you want to be objective, and how objective can it really be? Maybe as artists it's interesting to see a more subjective view of mapping.

JR: Yes, or by laying barriers around a process, or by forcing yourself to do the process that you're already doing (but a codified version of it), you can start to appreciate some of the translation that already goes on, invisibly. So the ideas of truth, veracity, and objectivity were tossed right out the window. You realize that everything's subjective.

The interesting thing is that, at this point, almost all of what we think of as "maps" are displayed as geographical maps, almost without exception. I found a couple of exceptions to that rule, one being Achilles G. Rizzoli's work, because the drawings are of buildings. They're not in any way representational of a map. I don't think it was until he died that these hundreds of drawings were found in his apartment. Another example I used is the architect Christopher Alexander, who has this perplexing book about objectivity in aesthetic forms. He posits that the rugs are a window into that person's vision of heaven, of the universe.

KV: You're referring to maybe Turkish or Islamic prayer rugs, not Western decor?

JR: Yes. Correct. So those are sort of our entry points into trying to veer away from the expected output of a map, which would be a geographical one, toward something else. This class was meant to expand the students' scope of understanding and their way of working. One student was actually trying to map the experience of smell and ended up producing a video of two bubbles converging—he was trying to map the experience of smell in real time as a video representation.

KV: So there's something going on there with synesthesia, where one sense suggests another, but also the difficulty of trying to map time if you're not using something flat, like a piece of paper, to create the map. If you're using video, then that's going to add another layer to it.

JR: Yes, another layer, or another dimension. The problem, of course, is that if you're going do anything in real time, it is going to be something other than paper. Furthermore, it wasn't geographic. The original idea he had was to go to all different areas of the Heights neighborhood in Houston and record the wind direction and the scents that he smelled. That's kind of interesting, but as soon as you say it, you can pretty much imagine what it looks like. To his credit, I would say that the video idea was pretty close to impossible. He was basically trying to represent smell as a color and ways to differentiate between hues.

KV: So basically, it was up to each student to come up with not only what they wanted to map, but the method that they were going to use?

JR: Yes. The projects in the class were actually the proposals and the process. And I guess the final project was the exhibition of the work at Lawndale Art Center. Some of the proposals were kind of wonderful and weird. For example, two women who collaborated, Evangeline Royer and Sylvia Sykula, wanted to work together because they're very good friends. However, they disagree about everything, and they're complete opposites. Even as they were trying to explain their collaboration ideas to me, they were arguing about it. They planned to go and find all the graffiti by a Houston-based artist named Give Up. Sylvia was going to document the graffiti, and Evangeline was going to face the other direction and interpret everything else, which is somewhat counterintuitive to mapping. Eventually they came up with this strange, multipart, photographic piece that included all the different graffiti they found. It was like a cityscape made out of photographs. For the final project presentation, they ended up hanging it from a window so that it blocked the light. Just like them, it was very contradictory, and it was very difficult to explain, and still is, even for me.

KV: What kind of parameters or guidelines did you give the students?

JR: I wanted them to use the process of mapping to accomplish what they wanted to do. And we went through that process many, many times. So what I wanted them to do was use this specific kind of research process, but what they looked at and what kind of interpretation they gave to it and what their final project was—it really was a case-by-case basis. And that has various degrees of success.

You can almost always get consistently better projects with very tight parameters. But my goal in this kind of class is to trip people up rather than to get them up the steps. I'm just upsetting the accepted situation—if there's a dark room, I change the furniture around. I have introduced them to a way to problematize what they do *and,* additionally, to recognize a process that other people go through that may be flawed. I think that's the important part.

KV: Yeah. It seems to teach them that you have to learn from mistakes—don't get thwarted, just go back and try again.

JR: Right. I've worked outside of the art world quite a lot in my life. Eventually you realize that there are processes that everybody goes through. We tend to expect that at a certain point there will be a level of perfection and then there will be a method to achieve these results. One thing I've learned as I've gone through life is that this never seems to happen. The methods are in place, and sometimes the methods are flawed, or the process of carrying out the methods is flawed.

KV: Yet these remarkable things do result from efforts that are very human. And sometimes the end product—whether it's experience, a piece of art, or whatever—is so great that we think it must have been the result of some pretty perfect people.

JR: And then you realize that nobody is perfect but that people are incredible. And I think that's one of the things the students learned from this experience.

KV: What do you look forward to as the CLUI continues work on its research for the exhibition *Texas Oil: Landscape of an Industry?*

JR: What might we be getting out of the CLUI's ongoing visits here? Well, we already got a couple of things. One is we've established the research outpost. We've also been able to work with the Buffalo Bayou Partnership, and I think they like working with us. We can share facilities, audiences, and events with them.

I'm hoping that the Center for Land Use Interpretation finds a way to keep a presence here in town—if not a permanently active office, at least some sort of dormant site. Because it has always been a loosely

knit group of people, we would like to be able to offer the field office to CLUI-related projects or other similar research projects.

KV: It's very generous of the CLUI.

JR: Yes, the CLUI is very generous and mostly an open network that I think has really produced some of the most interesting things I've seen.

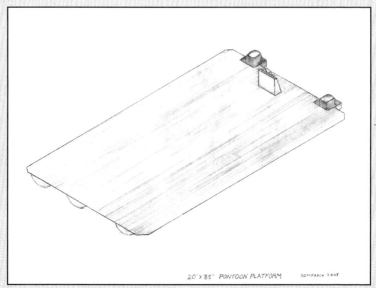

The platform in plain/universal mode.

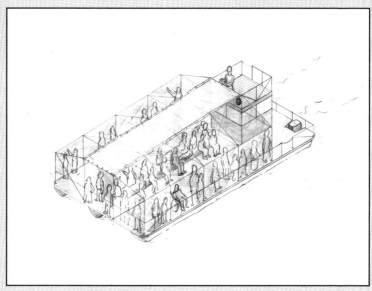

The platform in passenger/tourist mode.

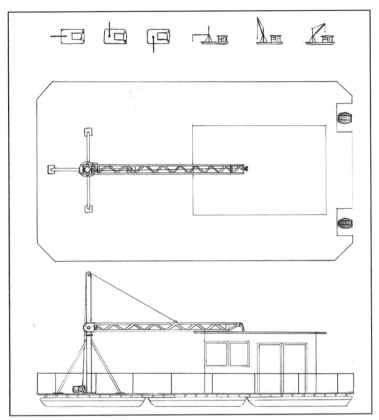

The platform in work/salvage mode.

CONCEPTUAL SKETCHES FOR SIMPARCH/CLUI PLATFORM

SIMPARCH was asked to consider ideas for developing a project with the Center for Land Use Interpretation, based out of the Buffalo Bayou field office site. Working with the CLUI, SIMPARCH developed the notion of a floating multifunctional space, a small buoyant landmass that could serve as a creative context for public programs. In passenger/tourist mode, the platform would be available for the CLUI's interpretive programs along the waterway and as a utilitarian work boat for salvage, placement, and transportation of artifacts. The platform would also be available for SIMPARCH's activities, such as water sampling, testing treatment technologies, and exploring autonomous living systems.

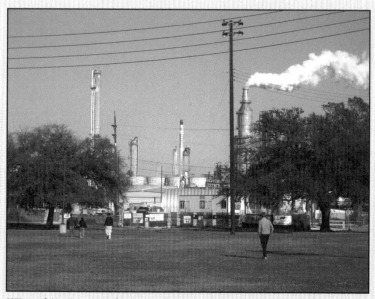

UH architecture students explore Hartman Park, a community park surrounded by petrochemical processing plants.

COLLABORATIONS AND INVENTIONS
PATRICK PETERS
IN CONVERSATION WITH
STEVEN STELZER

Patrick Peters, LEED AP, is director of the Graduate Design/Build Studio at the University of Houston in the Gerald D. Hines College of Architecture. He is also an architect and principal of Longoria/Peters in Houston, Texas. During the spring 2008 semester, he taught "zero — Buffalo Bayou Studio," a class that enabled thirteen fourth-year undergraduate students to collaborate with the Center for Land Use Interpretation.

Steven Stelzer, AIA, LEED AP, is program director of the Houston Code Enforcement Green Building Resource Center. He also coordinates the activities for Houston Mayor Bill White's Green Building Advisory Council, a group of building owners of LEED-certified buildings, and other leaders in the energy saving community. Stelzer's technical background includes thirty years of diverse architectural firm experience in Houston, with construction administration as his predominate focus, including such firms as Heights Venture Architects, Courtney Harper+Partners, RWS Architects, Bailey Architects, Kendall/Heaton Associates, and others. In addition, he earned his MBA from the University of Houston in 1989.

STEVEN STELZER: So, Patrick, could you please start by walking me through the books that your design studio made last semester?

PATRICK PETERS: These documents are now posted on the blog http://uharchitecture.blogspot.com [accessed August 2008]. The work was done in three installments in the early part of the semester leading up to the midterm review. The first book is the one that was created in the most collaborative way, and it documents the physical conditions of the Buffalo Bayou Partnership (BBP) site where the Center for Land Use Interpretation has its field office. Thirteen students went out to that area, which was recently a "pick-your-parts" auto wrecking yard; they took photographs and compiled a set of extensive field measurements to make scale drawings of the site, which is quite large — more than twelve acres.

The site right now has approximately four or five — depending on how you count them — existing metal sheds that are all in various states of disrepair; two are occupied by Houston Biodiesel, where they sell diesel fuel made out of vegetable oil. The students' challenge in this studio was to achieve carbon neutrality in the redesign of the location to accommodate BBP operations, which include cleaning out the trash of the bayou, training people about its ecology, and enhancing the use of the bayou by understanding the value that it has for recreational and ecological purposes. And also, there's a small program of about ten thousand square feet that the students had to insert into the site. It's an ecological laboratory that doesn't exist there now, but it's about the same size as the main industrial building. So they could choose to keep the industrial building, renovate it, and put the program in the building. That was the challenge.

I offered the students an insight — if they had a small building and a large open property with landscaping, it was possible to balance the carbon generation from the building process with carbon sequestration of the landscape, especially if the landscape was primarily wetland planting as opposed to sod or something like that.

Although the students weren't required as part of the studio to make the building carbon-neutral in operations, that was a major challenge for them to consider, including how it might be energy-generating. And to some degree, they took it on. But everyone took on the assumption that building less generates less carbon. Evaluating the degree with which rain water runoff moves through the site was also a challenge to deal with in its refashioning — either it gets contaminated, or is contaminated, or we don't want it to be contaminated.

So that's the setup from the first book, and for the second book each student got a descriptive page on which he or she estimated his or her individual carbon footprint for the year. And they ranged in the studio from just over five tons of carbon dioxide emissions to over twenty-one tons because some of the students drive very far every day just to get to school.

SS: Was the protocol for determining their carbon footprint something that they collaborated on and came up with?

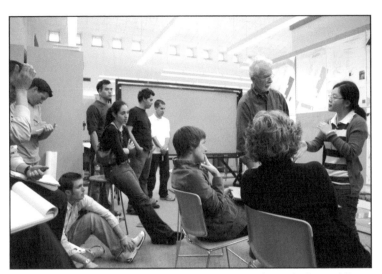

UH architecture student Sylviana Gunawan explains in her midterm presentation how her design for a building on Buffalo Bayou will filter polluted runoff water before it reaches the bayou.

PP: They all used the same calculator, which is the one that Al Gore points to at the end of *An Inconvenient Truth* [http://www.climatecrisis.net/takeaction/carboncalculator, accessed August 2008]. I showed the movie to the students in the studio, and that's the website we used. It asks general questions like, "How far do you drive every day?" and "What's your annual utility bill?" and things like that. It's interesting because the student that had the lowest carbon footprint in the class said, "Well, I drive an older, small Japanese car, with a very small, four-cylinder engine. And I live with other members of my family." So when you add those things up, the impact was tremendous, especially when compared to the other person on the opposite extreme who drives very far in a large pickup and presumably has high utility bills at home as well.

SS: One thing that the city is trying to do is get the low-carbon diet program out to the neighborhoods. And perhaps they could point people to your class' website. It shows that the students were out front, which is always a cool thing.

PP: So having done this calculation, which was not very complicated because it was a pretty general calculator, the students had a kind of

incentive to try to shoot for a low carbon footprint. So that became one of the criteria for their design ideas, as opposed to simply making pretty pictures.

One of the other conversations that came up was that, in most cases, the students had in mind to take the runoff water from the adjacent neighborhood, which has both industrial buildings and very modest residential homes, and filter it through the site. And the student designs brought that rainwater through some kind of aquatic life— plant, animal, or both. Being next to the bayou, the Buffalo Bayou Partnership site filters the rainwater runoff from the entire surrounding neighborhood, which comes through a storm sewer under a railroad track. One student's design filters the runoff into a series of basins that cleans the water.

Another student became the carbon sequestration expert for the class at the beginning of the term. He found that if you disturb the soil during construction, you're actually releasing carbon that's already sequestered in the soil into the atmosphere. Some of the students chose to do very little earth-moving for that reason, only to see how close they could approach the goal of building in a carbon-neutral way.

SS: Was there a collaboration in the development of the projects, or was the collaboration to take the students' individual projects and then have them work together?

PP: There were three possible levels of collaboration in my understanding. First, directly between the students with each other, but most of that occurred in the documentation and fact-finding. And then they started to work in a more diverse way. Second, between the CLUI and our class, and those are both things I believe were intended by the Mitchell Center and the people who created this. And lastly, there was the possibility of collaboration with the other two disciplines, the art and creative writing students, and that happened in less of a sustained way. It did happen on the days when we took joint field trips, which included going to a refinery — BP Texas City — which was pretty amazing. That was organized by one of the CLUI residents, and we did that together.

And we had an opportunity to see CLUI director Matt Coolidge, who was the first resident artist. All of the collaborating classes — architecture, art, and creative writing — sat in his lecture together, so we had sort of a common baseline. And then, at the end of the term, all of the class projects were displayed together at Lawndale Art Center for a public exhibition, and that was a collaborative experience. But mostly it worked through proximity. In other words, the conversation occurred because the work was exhibited in the same room. So where the collaboration was most intense was among the architects and secondly among the artists and architects.

What we had at the end of the semester were thirteen exhibition panels and thirteen models, which were displayed at Lawndale Art Center. We had a final jury there before the exhibition opened with an architect and a landscape architect, both LEED-accredited professionals, and Anne Olson, who is the director of the BBP. Also, some of the students' projects were submitted to the American Institute of Architects (AIA)'s exhibition and will be presented there as well. And then we'll probably put work in the BBP offices for another exhibition later.

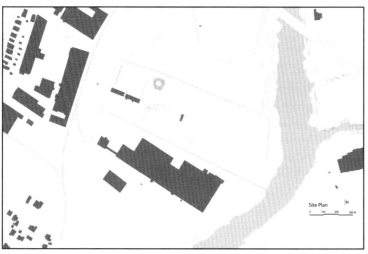

Site plan of the CLUI Field Office made by UH architecture students

SS: What about the idea of coming up with a group plan? Would that be useful? Is that a next step? What about an "all-star" rather than an individual approach?

PP: In this case, I didn't want to narrow the possibilities down to one idea. It allowed the students to test their own ideas through the whole set of the documents and models and drawings. You get the benefit of a sort of shotgun approach. You see the splatter on the wall of things that come out and would seem valuable.

We had one student who decided to replant the site in bamboo and then harvest it as building material. He discovered that bamboo sequestered carbon at higher rates than trees, and it grows of course much more quickly. It takes about seven years to plant the site and harvest the bamboo. I don't know that that would've necessarily been a primary direction to take in the studio if we would have focused on only one scheme.

SS: The fact that that student was all over that idea is wonderful. I'd love to see some entrepreneurs do that. Hey, home-grown Texas bamboo! What a great idea!

PP: And in his proposal, he was using it for building trusses and a rain-screen system, not just for walls, which is valid as well, but he was looking to make the whole structure of the building out of it, and it's pretty exciting. He found examples where it seemed very plausible that that could happen.

SS: I'd love to see it. That would be exquisite.

PP: Yeah, it really seemed like a splinter idea that kind of peeled off from the group.

SS: I guess another kind of question is—when you have a lot of student work and they come up with great ideas, how do you disseminate that to the public? I think one of the challenges with our current state of technology is that we're all kind of overwhelmed, and this work is kind of on the fringe for a lot of people.

PP: Well, I would say that that's the advantage of working with an institution like the Mitchell Center. They are a catalyst. They cause some of these things to happen, and the work doesn't have to stay here in the

CLUI director Matthew Coolidge gives a tour of the CLUI's site on Buffalo Bayou to instructor Patrick Peters and UH architecture students.

University. It's an excuse to take it out to the community and find ways to let people know about it. They caused us to have this blog. We probably wouldn't have done it on our own; it takes another set of steps. The website caused us to make these little booklets, and that's a progressive documentation tool. Through the Mitchell Center, Lawndale became involved, and we were able to put our work in Lawndale's gallery. And really, it's a related set of events that we submitted to the AIA, and some of that work will be in the AIA show. So having the sanctioning of the Mitchell Center caused great things to happen.

SS: Another one of the things that I feel strongly about, personally, is the need to engage the art community in these technical issues that we have as architects. Artists have a very high awareness of environmental problems. I think the synergy in that area between architecture students and art students is huge.

PP: No, I understand. I mentioned that I had done some previous collaborative work here before we had a chance to work with the Mitchell Center, and it was with an art class. Actually, the first time was three years ago and has happened twice with the same UH associate professor, Cheryl Beckett, and it had an ecological focus as well. We did it differently each time, but one of the two times we

actually had the students work directly on the same assignment together. It's not always possible. It's sometimes hard to get these things accomplished, but that was exciting.

SS: Yes, because both artists and architects are dealing with 3-D forms. And I think the artists, when they're out there in the world doing their projects, can then have the contacts. They can at the very least say, "Hey, I want to build something to make a statement, but I also want it to be physically viable," and then have help from the architects.

PP: And I think it's important to remember that, for us, the contact with the CLUI really came through UH School of Art director John Reed and the art community. I was aware of the CLUI through its publications and reviews of its exhibitions in the *New York Times*. But Reed brought its members in the flesh. And it was their peculiar way of seeing Houston that was so fruitful to us and motivated us. And what we produced had their fresh eyes as well. I think these relationships are all ripe for further cultivation and harvesting.

SS: Yeah, because that's kind of the way we got to look at the world — it's all about cultivation and harvesting. Do you think we've covered everything you'd like to say about your studio last semester?

PP: I think so. I guess I'd just like to sum up my point of view, and it really came out of our conversation. I want each studio that I'm involved in to be at its base a default ecologically focused studio. But it's my goal that soon this focus will not be distinguishable from any other studio. They will all be baseline, ecologically focused studios.

SS: I can't tell you how much I applaud that, because coming from my position as program director of the Code Enforcement Green Building Resource Center, that is my mission, to get that kind of information with an awareness of sustainability out to the public for our future. We all need to be making sure that our interaction with the environment is beneficial. Green building is about making better buildings and keeping the environment in mind. And we've got the whole carbon idea; we've got the 2030 initiative; we've got Al Gore; we've also got the whole peak oil idea. Hey, we need an alternative to everything.

And so getting these concerns on the radar of all the students — those coming out into the employment universe — is exactly what we need.

We need students to have this kind of consciousness so that when we design, it's automatic. You know we're going to design for a lower carbon footprint. We can't afford, as a culture, to be wasteful. And then the happy thing, in my mind, is that hopefully the business world is going to be able to take this young group in and let them do their stuff instead of deprogramming them and saying, "No, no, no, no, we've got to do this the way we always have." So hopefully that'll happen.

PP: Yes, these students are finding jobs with firms that welcome these ideas.

Concrete silos on Buffalo Bayou.

ALL EYES ON HOUSTON
ERIK KNUTZEN
IN CONVERSATION WITH
ERIN ELDER

Erik Knutzen is a program developer at the Center for Land Use Interpretation. He has applied a background in photography and interdisciplinary research to the CLUI's projects and has collaborated on the research and production of a number of their exhibitions and programs, including *On Locations: Places as Sets in the Landscape of Los Angeles*, *Pavement Paradise: American Parking Space*, and *Dissipation and Disintegration: Antennas and Debris Basins in the San Gabriel Mountains*. He is coauthor of *The Urban Homestead*, released in June 2008 by Process Media, Inc.

Erin Elder is an independent curator based in San Francisco, where she received an MA in curatorial practice from the California College of the Arts. She recently curated a process-driven exhibition of experimental artworks called *The Institute for Social Research and the Discovery of Art God* at the Richmond Art Center, which travels to Württembergischer Kunstverein in Stuttgart, Germany, in August 2008. Elder is also part of the curatorial collective In Situ, which is currently producing a multipronged project about the physical and social landscape of Richmond, California, for the Yerba Buena Center for the Arts's triennial exhibition *Bay Area Now 5*.

ERIN ELDER: Where to start is always the question. Maybe you could briefly just talk about what your involvement with Houston has been.

ERIK KNUTZEN: Sure. My involvement with Houston was to coordinate with three classes at the University of Houston. The classes were from the College of Architecture, the School of Art, and the Creative Writing Program. They were there to observe what the CLUI was up to, so I conducted some programs for them related to our work in general and more specifically, our research in Houston. The architecture class was interested in rehabilitating the CLUI's field

office in an environmentally sensitive way. Even though the CLUI is nonpartisan on such matters, we are interested in showing people the process of how things work, or how infrastructure works. I decided to take them to a concrete recycling facility called Southern Crush Concrete and show them how it works. A man named Jim Miller, who works at the company, gave us a really amazing tour of one of their crushing facilities.

What they do there is actually a kind of mining, where his company will demolish a building for you, for a fee. Then they take the raw materials, crush them up, and — in the case of the particular facility we were at — make them into a kind of material that is used for road bedding. At the site we visited, they have a huge piece of machinery that crushes the rock, which is sent down a conveyer belt where workers physically separate out some of the materials, pulling out rebar and junk that's in the concrete. It's crushed into smaller and smaller pieces, separated, and piled up. It's then mixed with sand and some other things to make a product that they resell. One of the things I loved about the tour was when Jim talked about how proud he was that the company had sold the same materials four times in a row. In other words, they had demolished a building, crushed it up, used it, demolished it again, and crushed it up again, four times.

EE: Wow! And they're able to trace that lineage of the materials?

EK: Yeah, it's an amazing business. We were standing on a big pile of materials, and he was able to tell us where a lot of it came from. And my memory doesn't serve me very well, but I think one of the piles was from a large mall that had just been demolished. Concrete recycling is a very common thing, but I don't think that most people know concrete is reused as much as it is. That's one of the things that the CLUI likes to show people — where these common, ubiquitous, boring materials really come from and how they're used.

EE: Why do you think it's important and interesting for the CLUI to show people those processes?

EK: There are a few different angles on that. While we don't have a political agenda, I do think we stand for a kind of transparency — being able to see the process of things and to see the physical

Erik Knutzen talks with UH art and creative writing students.

manifestation of economic and social aspects of our culture. So, for instance, we all know about the global economy. It's one thing to talk about it, and it's another thing to actually see it in action. That's why we did a show about the Port of Los Angeles. We also did a bus tour and a boat tour to physically take people to the port, actually show something real, and let everyone make up their own minds about our connections with the global economy. We may have an opinion one way or another about these things, but we are all part of this system.

EE: It seems like the CLUI is doing that kind of thing more and more, taking people into the landscape for extended periods of time. I was involved with the California College of the Arts trip to Louisiana. It was really interesting to be there for ten days or so, immersed in the landscape and the culture and what was going on there, really examining how people were dealing with the land disappearing as well as the problems created by Hurricane Katrina. It's interesting that the CLUI has gotten so involved with different universities and student groups. Why work with students? What's the value of taking them into the land?

EK: We value taking everybody to the land as much as possible. It would be an ideal situation if every exhibition could be physically taking people to these places. We would just do tours. But it's really hard and expensive to do that, so we can't do as many as we would really want. In a way, the exhibitions are the second-best thing to actually taking people to a specific location. And we also do guidebooks and have our exhibition halls in remote locations in an effort to actually get people to go to these places themselves and do a self-guided trip. So as much as possible, we really try to get people out there. As far as the colleges and universities, I think it's really an important part of our mission as a nonprofit organization to support educational institutions in getting their students to actually go and experience places. I think that education should be an experiential thing. Book learning is fine, but from personal experience, I find that I learn more when I'm actually having to build something, do something, or go somewhere. I mean it certainly is true with learning a language, right? You actually have to go to a foreign country to learn a language. You can't really learn it from a book, and it's the same with understanding landscape or architecture or art. Often it's mostly art and architecture students that we interact with, so actually going and seeing the physical things is really important, I think.

EE: I went to Prescott College, a school founded in the 1960s. They have a real commitment to field-based learning and self-directed study, and many of the classes would go out into the field for weeks at a time or for a few days at a time — not just science classes or geography classes, but political science and art courses, too. During my time there I learned that it's not just about going to a place and seeing it — that has all kinds of value — but it's also getting there, the things that you see along the way, the surprises that come up, and the people you encounter. All of that somehow rounds out the picture of a place or the experience of what you've gone there to see. The stuff along the way almost becomes more interesting than what's on the schedule or what's been planned.

EK: Yeah, the journey is the journey, right? Definitely.

EE: Yes, indeed. Education is a journey. I think it's interesting that the CLUI is still so firmly rooted in art and architecture instead of working

with, say, business or engineering students. It makes me think that there must be something about the lens of art that's important to the CLUI. Because your practice is so neutral, it could be interesting when applied to other fields. Why do you think it's important to keep working within the realms of art and architecture?

EK: Actually, I would love it if we had business classes involved. My favorite audience is when we have a group of senior citizens come by who have very specific life experiences, some of whom can actually speak to the industry, or subject, we have profiled—that's always exciting to me. It's just a matter of circumstance, really. I don't think we intended to focus just on art and architecture. Most often that just happens to be where the funding sources have come from, or maybe a little niche that we've been able to carve out. At the University of Houston, we worked with a class from the Creative Writing Program, so that was more of a stretch for us. But for the future, I can definitely see a wider spectrum.

EE: And what did the writers do?

EK: Well, since the art class wasn't necessarily focused on anything too specific, I was able to group them together with the writers for one of the trips. I took them to look at the margins between the built and the so-called "natural" landscape. We essentially walked along the bayou, and I pointed out evidence of human habitation in terms of the plant species and things like that. So the writing class was interested, as you say, in the journey more than the things we were looking at. They were interested in telling a story and their instructor, Mat Johnson, was basically trying to help them learn the process of telling a story through the landscape itself.

EE: I'm curious, how did he do that?

EK: By actually going out and doing things. I know that my career has shifted into more writing — having recently written a book and now doing some magazine work. I've found that the more experiences I have in life to draw on, in terms of these journeys, the more material I have for the wide range of writing assignments it looks like I'm going to be tackling in the next year or so.

EE: What might those experiences be?

Erik Knutzen leads a tour for UH art and creative writing students along the banks of Buffalo Bayou.

EK: Well, just an incredible variety of life experiences. It's been really great to work at the CLUI, to be able to go and see different places, and be associated with a wide variety of activities — everything from shipping to filmmaking. I even went to the Arctic at one point. These are all examples of experiences that someone can draw on and learn from, whether a businessperson, writer, artist, or whoever.

EE: It seems like it would be hard to maintain a neutral perspective after awhile. Maybe that's part of what you were talking about when earlier you mentioned transparency and not taking a political stance. I wonder what it's like for you to collect all these experiences and see all these places — just to be in a place like Houston for a period of time. How do you maintain your own sense of neutrality, or is that important? Is it OK if you become personally charged in one direction? How do you navigate all of that?

EK: The more I've worked with the CLUI, and with Matt Coolidge, the more I've come to value that attempt at objectivity. Of course we all have an ax to grind, and we are never really truly objective. But if you go into something with preconceptions, I think that's a mistake, so I've learned the value of maintaining that objectivity. It gives you more access to more people, to more places, to more experiences than if you go in with preconceptions. And it's also important to do your due diligence. That's another thing about the CLUI's approach — to try to exhaustively look at the subject with all the details and various permutations of whatever we're looking at. In the case of oil, we are looking at all the kinds of drilling, or all the kinds of exploration that's out there rather than, again, going in with a preconception and only focusing on one thing.

EE: So is it safe to say that something you hope your audiences would learn is that by going on these tours and looking at these exhibitions, it's not just material for them to examine but also a particular way of approaching the subject?

EK: Well, I think that's up to the audience. The interpretation in our name is there for the audience, less so for us.

EE: One thing I found fascinating about being at Wendover was the incredible resources that are available to the artists-in-residence —

everything from relationships with community members to access to very high-security land. The residency program has a real DIY aspect to it. There isn't anyone on-site overseeing everything, so it seems that the artists who are selected are trusted to maintain those relationships and take care of the place. Yet there aren't any demands that their artwork makes or preconceptions about how their projects should turn out. I find that to be a really interesting equation of trust.

EK: You're right. We like to select people there who can take care of themselves, who don't need to be babied in some way. I mean, there's no personal chef, there's no set program, and that's the way we like it.

EE: What do you think the CLUI gets out of sharing a place like Wendover with artists? Or being tour guides for these students and people in Houston? What do you get out of it?

EK: That's a good question. We certainly learn things from the audience, and their interests sometimes will motivate us to go places and do things we might not have done or thought of, particularly with the students and classes. The trip to Southern Crush Concrete was motivated by a wonderful UH architecture professor, Patrick Peters. His students' interest motivated me to go take a look and revisit a show the CLUI had done a few years ago about concrete, and then to look at the concrete industry in Houston. So, that's a good thing. And if we can find a balance between what we are interested in and what other groups want to commission from us, then that's a positive arrangement. In terms of the artists in Wendover, it extends our drive to explore the landscape, and so we have other people with other perspectives who can come in and expand that vision. They show the work in the exhibition hall there, too, which is a great and positive thing. So the artists that we invite might go places and do things we might not have thought of, and that's worked out nicely.

EE: It seems so timely to be examining the landscape, especially in an art context. I'm sure you are aware of many biennials and exhibitions and projects that are doing some form of land art or are commissioning site-specific projects. I wonder how you see the CLUI fitting into this trend. What do you think this land art phenomenon is about?

EK: That's a nice thing about the CLUI, but I don't feel any strong connection to the art world per se. We don't sell anything, and I just passively observe the art world and get the good things out of it from a distance. So I say it's great; the more the merrier. I don't even think about it anymore. I see art as just another tool to explore things. Not to compare the CLUI with a Renaissance artist, but my view of art is more, say, in the vein of how Leonardo da Vinci was an artist but also a scientist, so art for him was probably just another tool for exploration.

EE: I guess I've been thinking about this in relation to a curatorial collective that I'm a part of, In Situ. We develop projects that start by looking at landscape and then go in various directions, often uncovering the politics and social implications of living in a particular place. We are developing a project for a new land art festival in New Mexico next summer, and it strikes me that so many of these land-based festivals approach land art as simply "art on the landscape." Our collective believes that art is the place where intense discourse can happen, and we actively attempt to expand an otherwise limited dialogue by digging deeper into land issues. Land is so rich, and human relationships to it are so layered. After being exposed to the CLUI's method of investigation, I guess I get frustrated seeing so many different biennials and situations where art could be a tool for looking even deeper, but instead it's superficially placed.

EK: And the other thing of course is that the CLUI also says we don't really need to plop art somewhere, but that the art is already out there. We just have to take someone to the Bingham Canyon Mine near Salt Lake City, a big mining pit, and say, "Look at that!" We don't have to make anything, right?

EE: I love that! But, why is that art?

EK: Well, that would be for the audience to decide. But art is something you make, right? It's an idea. It's manifested in one way or another. Again, the CLUI looks at human-made things in the landscape. So something that humans do by hand or machine can be considered art, or at least considered in the same way that many art objects are considered. One of the ways that the CLUI works is just to broaden the notion of what art is.

UH art student Sylvia Sykula investigates the landscape.

EE: It seems to me that making an experience could be art too; that you're making experiences available to people.

EK: Sure, like Allan Kaprow and Happenings. Sure.

EE: In a previous conversation, you said that Houston was one of the most interesting and important locations in the world. I'm curious as to why you think that, why you want to make an experience available to people there.

EK: One word: oil. That's all I have to say. The world revolves around oil, and Houston is at least one of the main capitals of oil right now — certainly the capital of oil in America. And with four-dollars-a-gallon gasoline, oil is on everyone's mind right now. I think Houston's importance is pretty clear.

EE: I've never been to Houston. When you were spending time there, did you feel the presence of the oil industry? Do people talk about it — is it part of the culture?

EK: Oh, well one of the CLUI's volunteers, Mark Curtin, is actually in the oil business, so he would drop by the field office every once in awhile.

And though most of America right now is not doing so well, Houston is doing pretty well, and that's obvious when you are there. And it's obvious that Houston's activity was built around oil just by the way it's designed. The city has the biggest freeways you'll see in your life. It's sort of Los Angeles on steroids, and you definitely see that this place is different from other places in America.

EE: And everybody drives?

EK: Oh yes, everyone drives. Yes indeed. It's a vibrant city, and it's a lot like Los Angeles in many ways.

EE: Did you sense a concern among people about the impending oil crisis?

EK: Well, I can't speak for many, but certainly Mark is very busy right now. He's in the oil-field services business, so he's building large pieces of equipment and they're being shipped all across the world—so it's definitely a busy place. People are working hard and building exotic, expensive pieces of equipment because, of course, oil is getting harder to find. They're having to go to places that are further afield, so definitely you can see that in Houston.

EE: Do you see much of the industrial architecture in the city?

EK: Oh yeah, definitely. Houston is the largest city in America without a formal zoning code. So there might be an industrial facility next to a church, next to a school, next to some houses, completely at random. Matt Coolidge said it's like someone has taken the cloning tool from Photoshop and just sort of flipped it around and pasted stuff all over the place. That's what Houston looks like. You'll have a twenty-story building next to some residential two-story and one-story buildings—all kinds of craziness like that. And then of course there are refineries that stretch toward the Gulf of Mexico—amazing huge refineries as far as the eye can see. So yes, you definitely know that oil is there and that industry is there. That's unmistakable. And downtown is full of office buildings with the headquarters of the energy companies as well.

EE: Does this lack of a zoning code have something to do with the oil industry?

EK: I don't know, although I would suspect that is the case. It seems like a Texan thing, a Libertarian thing, too—with the city infused with the

spirit of oil and people being self-made. I can imagine you wouldn't want government telling you what you can and can't build.

EE: Like you said, oil is on everybody's mind. Did you feel that it was dangerous to be talking to local people about oil? Did you experience a sensitivity, a guardedness? What was it like?

EK: Nah. I really liked Houston, and people there are actually friendlier than in LA, and a little more laid back, I felt, so no, I didn't sense that at all. Now in terms of getting access to places — Steve Rowell can tell you stories about trying to get into the BP refinery. So yeah, that's a whole different thing.

EE: So what did this project in Houston do for you personally? I know you've just produced this book about your house and about growing your own food, and you mentioned that you ride a bicycle, and it sounds like you've really cultivated a certain sort of lifestyle for yourself and are thinking critically about it. What does a residency in Houston do for you personally?

EK: That's a whole other side of my life, but it's informed by the CLUI. And I don't really call myself an activist. I do all those things simply because I find them enjoyable. I ride a bike because I like to explore the world that way and not so much because it has anything to do with oil or pollution or anything like that — it's just an interesting and different way to see things. It was nice to go to Houston and again have a broadened experience and see places and experience things that I hadn't before. I got to take a canoe trip down the bayou, which was absolutely fantastic. I recommend it to anyone there, through the urban bayou.

EE: What's the bayou like?

EK: It's industrialized, in other places it looks kind of wild, and it runs through the middle of the city. I have a friend in Houston, Kirk Shaunfield, who is a bike person, and he went along with me on a canoe trip from the field station site and deep into Houston — under freeway overpasses, through golf courses, next to office buildings. It was extraordinary, and I know that SIMPARCH has seen this, and Matt is planning to do some more work that will make it possible to get more people out on the bayou and experience the city that way.

EE: I think that so much of the CLUI's activities are driven by, like you said, an attempt to exhaustively look at something. That way of operating takes you to all sorts of different places. Like riding a boat down the bayou — that takes a certain level of agency and follow-through. To have an idea and actually make it happen — seems like that's a big part of what people can learn from being a part of the CLUI's projects, learning to follow through with curiosity and see where it takes them, to go and see places they haven't seen before, go to the end of the road, or up against the fence. I wonder what tools people need to make that happen?

EK: That sums it up nicely. You're driving down the road somewhere and you pass a sign or a building that intrigues you. Most of us would keep going because we're busy, but the CLUI's approach is, "Nope, I've gotta make a U-turn here and go back and check it out." And that sums it up.

EE: On our trip to Louisiana with Matt, we had something like the "holler rule," which meant you could just holler if you wanted to stop. And at first it was really awkward to say, "Wait, what's that? Can we slow down?" But once we got into the practice of doing that, it made things

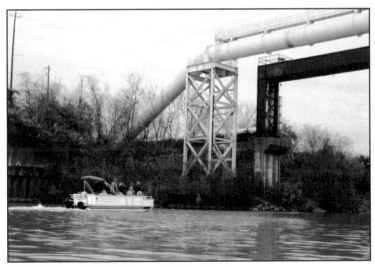

CLUI boat tour of Buffalo Bayou with UH students.

more interesting, and it became easier to speak up, easier to tumble out of the van and run over to see what was going on. But it seems like you have to cultivate the willingness to do it.

EK: Yes, absolutely. You've got to really focus on the things that we normally tune out — piles of concrete or whatever — and really focus on the ubiquitous or on the stuff that we overlook all the time.

EE: And again, I wonder what's the value of that?

EK: You know, the really important stuff is what we tend to filter out. I always think of the standard advice you see in a lot of beginner's manuals for landscape photography. In order to show how to frame something, they will usually have, for example, a power plant and a beautiful forest. You're supposed to frame out that power plant, right? And of course if you frame out that power plant, then you're not telling the full story. The CLUI's message is that you've got to include everything in that frame.

EE: I've been wondering how those things get erased from our way of seeing. For instance, my sister is a painter, and she paints industrial spaces, mostly factories. When we lived in the Southwest, she was painting these factories that were way out in the middle of nowhere — because they're removed from the city, you can understand why people wouldn't notice them, or why they become landmarks more than places people really understand. But then she recently moved to San Francisco and was very troubled by this industrial landscape imbedded in the city, and yet it goes unnoticed by most people even though they walk past it every day. It's led to several different conversations between us about the way people tune things out, or look at something and think they understand it, or know they don't understand it and decide that's OK. They don't even question it.

EK: Do you know the book *Drawing on the Right Side of the Brain* by Betty Edwards? It's a how-to manual for drawing. It's a brilliant thing actually, and it explains why people who don't know how to draw often draw stick figures because they're not actually seeing things the way they are. Instead, they focus on the mind's stereotypical representations of something rather than just an abstract form of some kind. For example, a face is an abstract shape, but we tend to

focus on two eyes and a smiley face and a circle. *Drawing on the Right Side of the Brain* shows you how to overcome your mind's stereotypes and actually see a shape and easily represent it. It's a great way to learn how to draw, but it's the same thing in our daily lives, too, where either we don't see things or we're focused on something else. Or it could be like when you're holding a hammer and everything looks like a nail, right?

EE: And yet, as you were saying, so much of our world comes from these places that we don't even notice anymore.

EK: Yep.

EE: I wonder if that is changing with some of the economic and environmental crises going on. It seems like maybe there is more of an interest among people about where things are coming from.

EK: Certainly the timing of our exhibition *Texas Oil: Landscape of an Industry* couldn't be better. Obviously people are thinking about that now. The CLUI shows tend to have an eerie timing about them.

EE: What do you think will happen as a result of this project in Houston? Are there plans for the structure that's on-site to have a long-term life?

EK: Yeah, certainly. And I hope that we are there forever. It's great and an important place, and I hope that it is part of the whole regional mission of the CLUI to explore the entirety of the U.S. landscape, so definitely I hope we're there for a long time. The actual practicalities involved in that I'm not so clear on, but it looks like we will be there for awhile. And I really enjoyed the Buffalo Bayou Partnership folks, they're doing interesting work there. And the Mitchell Center and everyone—it was a very supportive environment. All of the institutions we dealt with were really wonderful and generous.

EE: It all sounds extremely worthwhile.

EK: Sure is.

PANORAMIC PHOTOGRAPHS OF BUFFALO BAYOU

BY GEOFF WINNINGHAM AND "ZERO—BUFFALO BAYOU STUDIO"

Aerial view of Buffalo Bayou winding through downtown Houston taken by Geoff Winningham, who has been photographing the bayou for more than ten years. His study has been published in the book *Along the Banks of Bayou City: Photographs of Buffalo Bayou and the Houston Ship Channel, 1997–2001.*

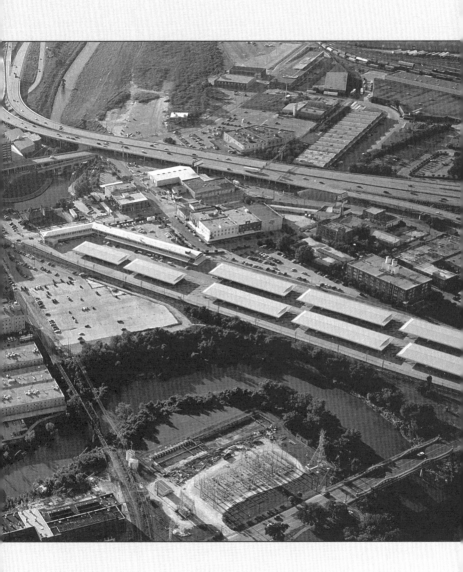

Aerial view of the stretch of Buffalo Bayou between downtown Houston and the Port of Houston Ship Channel taken by Geoff Winningham. The junkyard that was formerly on the site of the CLUI Field Office is just left of center.

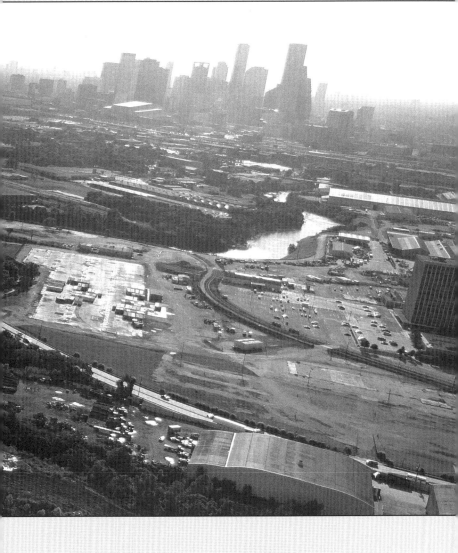

Panoramic photocollage of the CLUI Field Office site assembled by UH architecture students as part of their class "zero—Buffalo Bayou Studio."

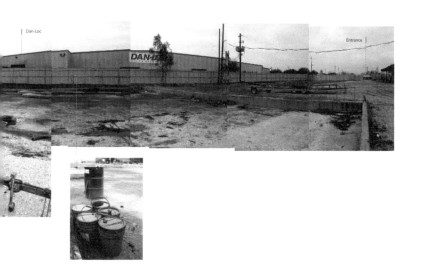

Dan-Loc

Entrance

Panoramic photocollage assembled by UH architecture students showing the CLUI Field Office site from the banks of Buffalo Bayou.

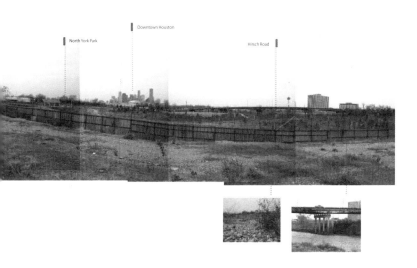

North York Park

Downtown Houston

Hirsch Road

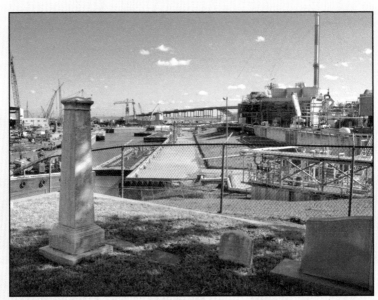

View of Rhodia Petrochemical Plant from Glendale Cemetery in Houston.

SPLINTERING PAST NONFICTION
MAT JOHNSON
IN CONVERSATION WITH
J. KASTELY

Born and raised in Philadelphia, Mat Johnson grew up in the Germantown and Mount Airy sections of the city and has lived elsewhere as an adult. His first novel, *Drop*, was a Barnes & Noble Discover Great New Writers selection. His second novel, *Hunting in Harlem*, won the Hurston/Wright Legacy Award. He has written for a variety of publications and recently published a book of historical creative nonfiction, *The Great Negro Plot*, and the critically acclaimed graphic novel *Incognegro*. Johnson currently teaches in the Creative Writing Program at the University of Houston and is the United States Artists/James Baldwin Fellow.

j. Kastely, director of the Creative Writing Program at the University of Houston, received his PhD from the Committee on the Analysis of Ideas and Study of Methods at the University of Chicago. He is a nationally recognized expert in the history and theory of rhetoric. His essays have appeared in *PMLA*, *Nineteenth-Century Fiction*, *Journal of Aesthetics and Art Criticism*, *Style*, *College English*, *Philosophy and Literature*, *Philosophy and Rhetoric*, *Rhetorica*, *Rhetoric Society Quarterly*, *Twentieth Century Literature*, and *Essays in Theatre*.

J. KASTELY: How did you become involved in the Center for Land Use Interpretation–related class?

MAT JOHNSON: Well, the CLUI was coming to town, and I think Nick Flynn was originally going to work with the class at the University of Houston, but he was on leave. I just got to Houston, and I'm really interested in the city itself, so this looked like the perfect opportunity to get to know Houston better, and actually, it was.

The other part was that a lot of the students that we have, I noticed really quickly, are in the city but they're not, so I thought it'd be a good opportunity to get them out and kind of interact directly with the city itself.

JK: And how did that work?

MJ: It was interesting. I mean, it was really hard [laughter]. Not that getting them to interact was hard, but the nature of the course meant that it was basically being re-created daily. What I thought the class was going to be before the term started turned out to be dramatically different two or three weeks into it, and I've never had that before. I usually have a set idea, and the course will move organically, but not to this degree where you don't even know what the class is.

Part of this was because we were starting to learn how the CLUI works and what it meant on a practical level to become involved in it. And then I think it was particularly tricky because we were writing nonfiction. So we had to find the nonfiction story that was, you know, in this world that we were being presented with. That was really tricky and I think, ultimately, we ended up splintering past nonfiction and had some fiction as well, just to capture all these really magical, industrial places and use those creatively.

JK: So, if you were to do it again, do you think it would be any easier? Do you think the nature of the class would be continually reinvented each time it's presented?

MJ: I've got to tell you, as a teacher, at times it really scared me to not have that kind of control that I think you depend on. But I definitely would be interested in the future in doing other projects like this. I think what I'll do, in those first weeks, is structure an idea about trying to get a handle on what the class actually will be, as opposed to coming up with one notion and then trying to get it to fit that.

But I think just learning how to connect with other artists outside your own medium is something that I like. I think as a professor, it's something that really forced me to grow, which you always want. And I'm hoping that I'll learn to avoid a lot of the mistakes we made this time, and of course create a lot of new ones to make in the future.

JK: If the nature of the class *did* change throughout the course of the semester, how did it change the interactions between you and the students?

MJ: I think when you teach, even if you try to reinvent the wheel a lot, you find yourself responding to the same questions. The parameters of what you're dealing with can be repetitive. And I found that's a good thing a lot of the time because you get better and better, [laughter] you know, at getting closer to the same truths.

But I think one of the interesting things about this course was that it was nice to kind of flip it up, that there were totally new questions coming up in response to things that happened. Like we did a site visit to a cemetery that overlooked the ship channel in East Houston, and we had to walk away from that and say, "OK, what are we going to write about?"

If it was poetry, I think it actually would've been relatively easy because we could've just responded, or if it's fiction we could've looked around and just imagined what this world was or who some of these people and these graves were and gone on from there. But

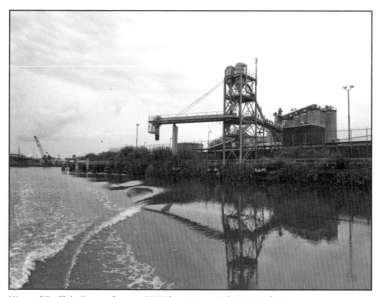

View of Buffalo Bayou from a CLUI boat tour with UH students.

UH creative writing students and Mat Johnson at Glendale Cemetery.

for nonfiction it became a lot more difficult, because we had to find somebody who had a story there, and there are no people out there, so how do you find it?

There were questions like that that I usually don't encounter in a class, and I know they're the kind of questions you actually *do* encounter in real life if you're working for a magazine or other places. That's what I fell back on, thinking about those times when I've been hired to do profile pieces and other types of magazine pieces, and I had to create the story from a creative perspective. So yeah, I think it forced me to flex muscles that don't ordinarily get flexed.

JK: Cool. So tell me, how was it to work with the CLUI? Did its methodologies help you or hinder you? Were you indifferent to them? What particular role did they play in the class?

MJ: At some point, I think the fact that they put us into positions where we weren't comfortable definitively helped us in a lot of ways to move forward. But one of the things I was reminded of is that the creative process in installation art and the creative process in prose writing are very different. The type of art that the CLUI was doing, the type of installation — you could call it art, you could call it science, whatever it is — so much of it is about exploration, and you just kind of walk out, and you see what you can find, and you just go in that direction.

Prose is a lot more deliberate than that. You experience life that way, but when you actually sit down and write, unless you're doing kind of free thinking or free-verse writing like William S. Burroughs, usually you're planning everything. There's a very set structure.

So it was very challenging, and I don't know if they had a complete understanding of that, because they just don't think that way, narratively. But of course, often the writer's challenge is to do that, to make sense out of chaos. [laughter] And from my perspective, it was really tricky. One day we went and visited some abandoned wheat silos. We went inside them, and then we just walked the park area around it, and that was it. So what do you do with that? You know, it's fascinating, but if you're trying to write the prose, the stories, that's really kind of tricky to negotiate. So what we eventually found to be most helpful was to just use these things as inspirations.

One of our students works at a senior center, and so she interviewed people about their experiences with the bayou that all this was set around, using inspirations like that. But I think we couldn't follow the CLUI in a kind of literal sense, just because the two structures were so different. If I could've done this course again, though, I think poetry probably would've lent itself a lot better to the collaboration with the CLUI.

JK: Looking back, what do you think worked best in the course?

MJ: Let's see, I think it was getting the students into positions and places where they never would go ordinarily. We took them out on a boat, onto the bayou. We took them into this area where homeless people in eastern Houston used to shower and change. And getting people to see these other parts of the world and to look at them — so much of what the CLUI seemed to be doing was to identify places that nobody ever looks at, really look at them, and also look at them from a perspective that brings value, or applies value, as opposed to just dismissing these places.

So just adding that point of view to the students' minds was important, and hopefully they're going to take that and begin to look at settings and characters with this idea that you don't have to look from a fixed position. Now they have a completely new perspective

that has nothing to do with mainstream reality. I thought that was rewarding. So on one hand, it was very difficult to take these field trips to these really odd industrial wasteland places and turn those into a narrative. On the other hand, just the idea of looking at the world from a perspective that hardly ever gets promoted was extremely helpful.

JK: I have one final question. Since this is a course that came out of the University of Houston Cynthia Woods Mitchell Center for the Arts, did you feel it had a collaborative aspect, or were the individual disciplines pretty much on their own?

MJ: The tricky thing about having a course that is in flux and in the air is, just like most courses, by the time you nearly get your feet on the ground, the class is almost over. So what I'm hoping is that I got my feet on the ground firmly enough, that when I do the next course I'll be able to hit the ground running. I would like to have set up more group assignments with the other professors. But by the time I realized that that would've been a good idea, we were already more than halfway into the term.

The exciting thing about these collaborative courses is also the most difficult thing. It's that you're reinventing the wheel, and because of that you're going to have all these revelations, all these new pathways that you didn't expect, and that's fantastic. But you also hit a lot of pitfalls that you've never expected before, either. So, hopefully the course gave the students something of worth to walk away with, and I think as a professor it definitely did. But it was even more rewarding knowing that I'm not an adjunct professor who's going to be here for five minutes; I can be here long-term, and we can actually build toward making even more out of these classes.

The channelized portion of White Oak Bayou upstream from its confluence with the Buffalo Bayou.

OIL: A FORCE OF NATURE AND A FORCE OF MAN

STEVE ROWELL
IN CONVERSATION WITH
SCOTT BARNES

Steve Rowell is an associate director at the Center for Land Use Interpretation. In the spring of 2008, he was part of the CLUI residency in Houston.

Scott Barnes is director of conservation for the Buffalo Bayou Partnership, a coalition of civic, environmental, governmental, and business representatives responsible for developing and facilitating improvements to the Buffalo Bayou greenway system.

SCOTT BARNES: So, let's start with a basic question. Is the CLUI interpreting land use or is it studying how land use is interpreted?

STEVE ROWELL: We are the interpreters, but we also consciously consider and explore the mechanisms of the interpretive process, though this is often more implicit than explicit in our work. Mostly we are interpreting space and place, what we refer to as land use. "Land use" is a term that can mean very different things in academia or industry. It typically refers to everything on the surficial layer of the planet. One could say that we interpret geography, but that isn't specific enough. Instead of saying "geography" outright, we say "land use," because we want to specify that we're looking at the human-altered environment.

SB: Right. So "land use" could mean a way of living or using resources, such as for farming or for energy?

SR: Yeah, anything that's basically affected by humans, so it involves the landscape, it involves the environment. We're using this term "interpretation" to speak to ideas of phenomenology, experience, and place. How do you re-create the sense of a place for someone who hasn't been there, or how do you re-create an experience of that place on subsequent visits? This is an impossibility. It's a conundrum of sorts that we can play with.

SB: So, what were you specifically doing in Houston? What were you studying here?

SR: We have three components of our research in Houston: oil, water, and aggregates. Primarily, I came here to start up the oil component of our research. Erik Knutzen was looking at aggregates, which includes everything from gravel, concrete, and minerals used by the city to build itself and how that was mined, sold, distributed, and transported up and down the Houston Ship Channel and throughout the city. Matt Coolidge has taken on water, which the city has quite a bit of at times — the bayous, the ship channel, drainage, egress, etc.

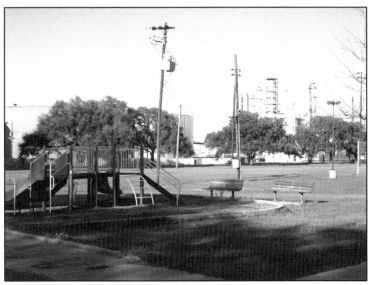

Hartman Park in the Manchester neighborhood of west Houston.

I've been working on the oil aspect. We identified three components of the city of Houston — water, oil, and concrete — and are interested in how these things relate. Now that we're moving into production mode for an exhibition about oil, all of us will focus on this aspect.

SB: OK. And *how* exactly were you studying the land use related to oil? I think it's easier for me to conceptualize what Erik and Matt were doing with aggregates and water.

SR: The methodology starts off with maps — finding where oil facilities

are located, dividing the "upstream" from the "downstream." There's not much "upstream," or drilling, left in Houston at all, but there's still quite a bit of drilling going on in other parts of Texas, especially now with the skyrocketing price of oil. The "downstream" here in Houston consists of huge tracts of land dedicated to nothing but the processing of petrochemicals, refining, distribution. This is how the land has been affected on a kind of literal level, but also on a conceptual level in terms of how people view the city.

People view the ship channel as this kind of economic vehicle that has created the city and that supports the city. The ship channel, of course, is there primarily nowadays because of oil. The city of Houston is really there because of oil more than anything else. Oil is a force of nature as much as it is a force of man.

SB: Right. And the surrounding cities — especially Newport and Pasadena — are especially dependent on the oil industry and the refining of oil, because almost everyone out there works in one of those plants.

SR: In fact, that's true of the whole Houston metro area, Harris County, and the surrounding counties. Port Arthur had one of the largest refineries in the world when Texaco built there in 1902.

SB: Yeah, that's where a lot of our reserves are, from what I understand.

SR: Exactly. The strategic petroleum reserves in Freeport and Winnie. Basically you're looking at two critical components for national energy needs here on the Texas coast. There's also the hidden infrastructure of oil — the pipelines. This invisible infrastructure can be read only by these brief bits of information — occasional signs that poke up from the ground — warning of hazardous material below.

SB: When you go through your research, do you study the historical components of how the oil industry has progressed here and how it came to be such a force?

SR: Yes we do, and the research involved quite a bit of that: looking at the original sites and how they've evolved over time. But basically, as a view of the city, we try not to present every aspect of a particular subject or every single site that we can find. We're trying to look at exemplary sites and singularities, like the oldest, the biggest, the

J.L. Proler Iron & Steel Company across Buffalo Bayou from the CLUI site.

highest refinery, and so on. Then we create a framework from which we can construct a sort of meta-view of the landscape and present it in a way that gives us some room to contextualize a bit and do what we do—interpretation. We're not just using the facts or history. We do a lot more than that, and that's the creative part, getting into the interpretive layers.

So now for the *Texas Oil* project, we are asking, "How can we contextualize all this information?" And really, we're still in the documentation stage. I have to do more photography and videos and recordings in the field before we make the exhibition for Blaffer Gallery.

SB: Are you finding more information on how the bayou, ship channel, and oil industry relate to one another?

SR: Well, in terms of the ship channel, it is the main artery. I think it's considered the second largest port in the United States in terms of volume. I think Los Angeles is the largest in terms of dollar amount, because of the electronics that come in from China.

SB: That traffic in the Port of Houston—that volume is directly related to the oil industry?

SR: Yeah, very much so. It's liquid volume. See, you have all these petrochemical products leaving the port. There are thousands of

different things that come from oil as by-products — gasoline, of course, but also fertilizers, chemicals, and substances used to make plastics.

But it's unclear, again, how much stuff goes by ship and how much goes out by the pipeline. It's really hard to trace that. One of the most interesting, Colonial Pipeline, has its intake in Pasadena, Texas, and it takes in quite a few things, goes up the coast of Louisiana and all the way up to New York, eventually.

SB: Wow, I had no idea. Do they put one type or various types of material in the pipelines?

SR: There are multiple pipes inside a giant underground pipeline. It's a pretty impressive feat of engineering. Along with the ship channel in Houston, it'll be one of those things that will linger for many, many years. It's very well built, but the potential for spillage can be frightening. These pipelines contain so much toxic material.

SB: And you're studying the pipeline, aren't you?

SR: In terms of the research we're doing? Yes. Pipelines, refineries, drilling operations. It's all part of the up/downstream of the industry and, by extension, the land. The toxic quality of the "product" in relation to the land and communities nearby does create a tension.

SB: Yeah, that's how I got interested in environmental science. You know, I grew up in Pasadena, very close to all the refineries. The north wind would give us a stink where we were. It was kind of embarrassing that I grew up there. But when I graduated from college, I realized that it was more important to come back here to be an environmental scientist than to stay up in the national forest where I was working. There was nothing to do out there. Everybody loved the environment, everybody wanted to preserve it, and it *was* preserved. I grew up in a refinery town, I know where the nastiest stuff in the world is, and I'm sitting here in a national forest. So that's why I came back to Houston.

SR: This is where you are the most needed. I think environmental scientists are needed here more than anywhere else in the country. And that's also why what the Buffalo Bayou Partnership is doing is so important, especially when you consider other urban waterways like, say, the Los Angeles River. That's a fairly dead river, at least in how

it's perceived. It was channelized after a catastrophic flood, but now most Angelinos completely disregard the fact that there's a river running through the middle of their city, whereas Buffalo Bayou in Houston seems more attached to the city. People have a closer relationship to the water in a lot of ways in Houston.

SB: Channelizing bayous here at one time seemed to make sense, because the idea was to move the water out faster if there is a flood. But in reality, the rivers are tidal, so the water doesn't go anywhere. If you're at sea level, it is more effective to allow the bayou to flood over its bank and absorb into the earth.

SR: Yeah. But with White Oak Bayou in Houston, parts of it have been channelized and have engineered flood basins. It's where the aggregate and water we are studying come together. And then there is oil runoff into the bayou from parking lots and such. You have this incredible feedback happening with these three components.

SB: Could you say a little more about how you worked with the students while you were here and introduced them to these three elements of aggregates, oil, and water?

SR: Well, when I was in Houston, I brought students to our logistics site, our trailer, where they talked about their own projects, and I also took them on a few field trips. There was one day in which all of them were invited to the BP plant in Texas City and got this tour of the plant perimeter by BP officials. They gave us a presentation about plant safety and the history of the recent explosion and how safety has improved. It was a way for them to improve public perception of their plant. That was the way to get the students out in the field and actually show them a refinery up close with details that they couldn't get otherwise.

Then there was another event in which individual classes came out, and I took them to see these green spaces along the ship channel and experience it from the vantage point of a green space. Of course, there are very few of these left in the industrialized ship channel. The few that I found all had these interesting views of the industrial surrounding. I chose Glendale Cemetery and Hartman Park. Both are on the very fringes of Houston, just inside the city limits.

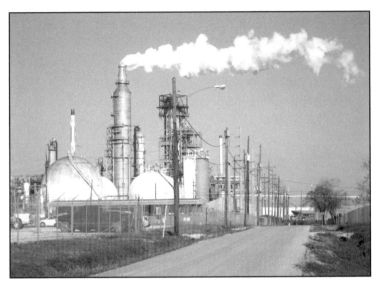

Valero Houston oil refinery adjacent to Hartman Park.

Hartman Park is a tiny, tiny park, basically two city blocks, where there is a baseball diamond with some barbecue grills. There's a community building in the park, too. But it is right next to the Valero plant. So you can sit there in the park and watch a game as well as the plant with its exhaust towers and the freeway overpass coming over the ship channel, another kind of industrial element. The community building in Hartman Park even has this mural painted by neighborhood children that has all these industrial components — the oil refinery, the freeway, and the helicopters flying over — in this kind of cartoonlike drawing of their park. Pretty incredible. It's sort of like a microcosm of their environment.

And then Glenwood Cemetery. It has John Harrison's grave, which of course is who Harris County is named after. The cemetery is right there overlooking the Houston Ship Channel. It's strange standing there looking at his grave with this industrial landscape surrounding you — ships loading and off-loading their various products, chemical plants doing what they do. Pretty fascinating.

SB: When you mentioned green spaces along the ship channel, I thought you meant the wetland that Agrifos Fertilizer has made. Their environmental supervisor once took me out to this pond in the

back of their plant. They basically built a wetland because of the environmental problems that they had. It was cool to see these wetlands right in the middle of this fertilizer plant.

SR: Yeah, I actually drove by that and photographed these huge human-made berms. Hopefully we'll try to get an official tour of it. The fertilizer components of the ship channel are often overlooked, but they are by-products of the oil industry as well.

SB: Let's see, I think we've touched on industrial residential relationships and the suburbs that surround Houston. Do you want to go into any more details about that?

SR: We're looking at sinkholes, of course, and brownfields, toxic sites, and superfund sites in Harris County. And outside of Harris Country there's a submerged town near Baytown. Occasionally, when you do too much altering to the sub-structure of the earth's surface, it can have unintentional consequences and strange things happen. It happened again about a month ago northwest of Daisetta in Liberty County. There was this huge, growing sinkhole. I think that was caused when an underground dome that was storing salt brine from oil fields collapsed. Something caused a rupture or leak out there, and of course the storage tank became hollow and collapsed. At one point, they were afraid that it could eat up the entire town.

SB: So, these types of sites are in many different places. Why is Houston specifically of interest to you?

SR: It may be obvious, but it's important to underline this point. We chose this place for a very particular reason. It's a sort of ground zero, if you will, of energy needs and energy production in America. The history of oil has been a very important part of this city and has made it a very important city in America and in the industrialization of the twentieth century.

The water and aggregate components of Houston are crucial as well because of the fact that it's such a hyper-developed city with a complete lack of zoning laws. It has to grapple with hurricanes, sometimes multiple times a year. It's a very dynamic city. We're not out to criticize; we're out to interpret. Houston is one of the most fascinating parts of the country right now.

And then in terms of why I am interested, do you mean why we're interested in oil now?

SB: Why is it of interest to *you?*

SR: I've worked on a series of projects about the automobile in Los Angeles because it's such an unavoidable part of daily life there. So the CLUI looked at traffic and parking and freeways and roads in the city. In a way, our study of oil is sort of an extension of how the automobile changed America. But now we're tracing it back to oil, which is what really changed quite a bit about America. It gave the automobile a reason to exist. Oil is something we've wanted to study for a long time, and it's such a pressing topic right now as this massive economic bubble forms around the cost of oil and the demand for it. And we all know that quite a bit is happening globally as a result of this need for oil, in the Middle East in particular. So it's a subject that we knew could be overwhelming, and in a way we had put it off until we had this invitation from the University of Houston Cynthia Woods Mitchell Center for the Arts to come here, and dive in. This has really given us the opportunity to focus on oil as a subject, completely.

We are going to start with Texas and Gulf Coast oil, of course using Houston as our primary focus and headquarters, and then in the

Community mural in Hartman Park.

Park at J.L. Proler Iron & Steel Company.

years to come, we will look at the entire country's oil landscape, if you will. We'll hopefully be going out to Alaska, New York, Pennsylvania, Oklahoma, New Mexico, Colorado, etc. It's not only a timely topic but also one that can potentially become very political. Remaining objective about oil is crucial, we think.

SB: Is it difficult for you guys to interpret without judgment?

SR: Yeah, I think that's one of the biggest and most common questions we get. How do we stay neutral?

SB: Exactly. I mean, it's human nature to put a value to something and judge it as you're interpreting it, as you're learning about it. And I think that one of the coolest things that I'm finding about the CLUI is that you're very much trying to stay neutral and stay balanced while looking at this. It's one thing to be an observer. But you are actually going into these places and staying neutral.

SR: I think it's because it is a known process. We are a 501(c)(3) and have an official mission to maintain. We're not functioning as individuals when we're doing work at the CLUI. So that is part of our agenda, to maintain this voice that can be read by anyone in the public and to be

an educational organization. And also, we want to do justice to the subject matter and the places that we're looking at, which deserve an unbiased viewpoint.

I did have a question for you. I looked through some of the master plans of the BBP and proposed ideas in the near future. Is the city actually implementing some of these designs?

SB: Yeah, oh, yeah absolutely. We're working with Flood Control and private property owners to push our ideas forward. Some parts we've already accomplished, such as the promenade along the bayou. But you know it's odd that Houston is known as the Bayou City, because it's really the county government that's much more interested in Buffalo Bayou.

SR: And that's because of the lack of zoning laws in Houston?

SB: Well, you know, even without zoning laws, we can still talk to private land owners, like the people across the bayou from our site, Proler, the metal recycling people. They have the last barge system that comes up this way. Because we're here, and because a park got redeveloped right next to us, Proler has seen the writing on the wall. They realize that Buffalo Bayou is turning into green space. So we encouraged them to talk to the Port of Houston and ask for a piece of land further down in the port. And we're helping Proler find developers who will give them a good price for the land they currently have. They are really good people over there. And so within the next five years they'll be gone.

SR: Oh, you think so? Five years? It seems like they're doing really, really well right now.

SB: They are the biggest metal recycling company in America. They pull in $15 billion a year. And you know what the funny thing is? It's cheaper for them to put every single piece of recyclable or other kind of metal they get on a barge, send it to China, process it in China, and then ship it back than it is for them to process it here.

SR: I've heard this. Yeah, it's mind-blowing. That the price of the fuel required to send a ship across the Pacific Ocean is balanced by the incredibly cheap labor.

SB: I know. It's absolutely incredible. But more important are the environmental laws. And that's the real cost these days — the expense of adhering to environmental laws.

SR: It's so interesting to see Proler as part of the big picture, the import-export, the trade deficit. It's all manifested in this port, these cars being ground up to be sent to China, turned into something, and then sent back to America. It's amazing.

It's so direct and literal, but somehow potentially very confusing. It's actually the sound track of Houston—its cargo rail industry with all of its noises and constant low-frequency drone. You can actually sense how much cargo is going in and out of the city. It's part of its dynamic nature. At times there are these features that one could find irritating or annoying or unhealthy, but you put them all together and it makes the city quite a fascinating place to look at, to interpret.

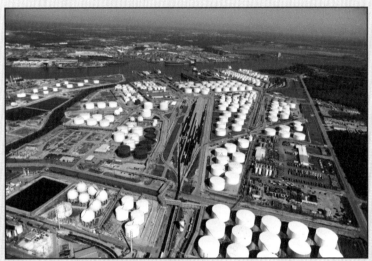

Kinder Morgan Pasadena terminal facility.

INDUCTION AND INTUITION, ON THE CENTER FOR LAND USE INTERPRETATION'S METHODOLOGY

In early 2008, the Center for Land Use Interpretation came to Houston, Texas, as artists-in-residence with the University of Houston's Cynthia Woods Mitchell Center for the Arts. I had only recently moved to the area myself. When I accepted my current position at Blaffer Gallery, I knew very little about the city and was surprised to learn that this sprawling metropolis is in fact the fourth-largest city in the United States by population with a land area greater than that of Los Angeles.[1] Houston may have a low profile in comparison to other large cities in the United States; however, its anonymity belies its economic power. ConocoPhillips, the city's wealthiest corporation, posted an astounding quarterly net income of $4.37 billion in early 2008, and the Bayou City is second only to New York in the number of city-headquartered Fortune 500 companies.[2] Houston is often perceived as a city that exists on the margins of culture, but it is a sleeping giant positioned at the very center of today's energy concerns.

Yet not once did CLUI founder and director Matthew Coolidge or members Steve Rowell and Erik Knutzen ever mention such statistics about Houston during their residency. They did not quote numbers or percentages when working with UH creative writing, art, or architecture students on Buffalo Bayou. Instead, they pointed out bizarre juxtapositions of industrial and green space as they conducted boat tours and research trips with students, snapping pictures and inventing beautiful metaphors for the bayou, calling it a "digestive tract" collecting anything that falls into the storm drains and run-off water of the city, proof that there is no "away" to throwing things away.

The CLUI's pontoon boat tour down the bayou through the center of Houston allowed the students and me to see this rarely traveled waterway up close and in detail, revealing such hidden surprises as unused century-old railroad bridges and makeshift shelters accumulated under highway

1 Figure 3: Top 40 Cities in the United States by Population: 2005 and Table C–1. Cities—Area and Population, *County and City Data Book: 2007,* U.S. Census Bureau, http://www.census.gov/prod/www/abs/ccdb07.html, accessed June 16, 2008.
2 "Quarterly Profit Rises 37% at ConocoPhillips," New York Times.com, January 24, 2008, http://www.nytimes.com/2008/01/24/business/24conoco.html, accessed June 16, 2008.

overpasses.[3] Most people first encounter Buffalo Bayou by crossing it on highways 45 and 59; some walk through parks and neighborhoods along its western banks. But there is very limited public access to the eastern half that runs from downtown Houston to the ship channel. Until recently, this section of the bayou was used mostly by industries such as a scrap metal yard and the city's sewage treatment plant. Thus, the boat tour through the

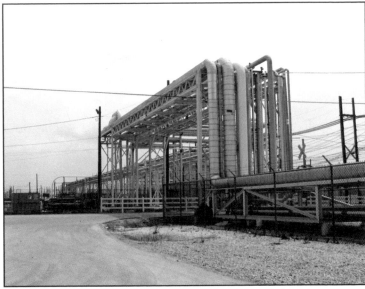

Pipelines crossing the street at a Deer Park petrochemical plant.

east bayou was subtly disorienting, as these rarely glimpsed sites lie not only in the heart of the city but in close proximity to the Houston Ship Channel, the main vein moving refined oil from Texas to the rest of the world.[4]

We are accustomed to directly observing only those aspects of the world that are part of our daily routines, while most of the infrastructure that supports our lifestyle goes unseen, from plumbing to the processing of the natural resources that power our homes and workplaces. These invisible forces can also serve as metaphors for intuitions that we cannot quite

3 Steve Rowell's photographs, many of which are reprinted in this book, capture these sites, as does Geoff Winningham in *Along Forgotten River: Photographs of Buffalo Bayou and the Houston Ship Channel, 1997–2001* (Austin: Texas State Historical Association, 2003).

4 See "Amidst a Petrochemical Wonderland: Points of View along the Houston Ship Channel," CLUI newsletter *Lay of the Land* (Summer 2004).

grasp, those things that we can visualize but cannot understand. In other words, the true nature of our civilization and the workings of our lives often lie beyond what we see, and even if we can see it, it can elude our attempts to fathom it. Beyond basic information, what can we say about the origin and function of materials such as concrete, water, and oil that constitute our day-to-day experience? We lack a basic epistemology of our material culture.

This is the challenge the CLUI has set out to face. It seeks a more complete understanding of the human relationship with the land and natural resources through the revelation of surprising facts. To this end, it is intent on improving the clarity and accuracy of its observations rather than proving any particular claims. That is an especially tough row to hoe when it comes to land use, a subject fraught with political conflicts that include the debate over how, when, where, and whether oil should be refined. The CLUI will present an exhibition at Blaffer Gallery on oil in Texas. But it is determined to avoid any agenda. It prides itself on producing books such as *The Nevada Test Site: A Guide to America's Nuclear Proving Ground*, which has been praised by antinuclear activists and Department of Energy officials alike.

The Center for Land Use Interpretation's mission statement proclaims that it is "dedicated to the increase and diffusion of information about how the nation's lands are apportioned, utilized, and perceived." Thus, its process is typically twofold: first, to conduct new research; and second, to present that research to the public. Step two of its method usually consists of writing entries for its Land Use Database; publishing collections of these entries; making multimedia exhibitions on certain themes or locations; and conducting tours of the sites that inspired its research. In its studies, the CLUI is more invested in discovery than overt analysis, and as it presents its findings, it leaves room for its audience to draw individual and independent conclusions.

As curator of the Center for Land Use Interpretation's exhibition *Texas Oil: Landscape of an Industry* at Blaffer Gallery, I have experienced the degree to which the CLUI's neutrality can make some people uneasy. Moreover, its liminal status between the worlds of art and science often confuses those who first encounter its work. Normally, an art museum champions subjectivities, yet here are artists/researchers who strive for objective observations. The CLUI's research-based presentations sound as if they could belong in a museum of natural history, yet its displays are informed

by a history of conceptual art and photography from Ed Ruscha to Henry Wessel. Both photographers have typically issued deadpan observations of land use in order to critique the homogeneity and excesses of a society that would pave expansive swaths of land just to have a space to store their vehicles, or encroach on the beauty of the western landscape with nearly identical tract homes. Many question whether the CLUI might have a similarly critical intent when documenting oil refineries, pipelines, and tankers. However, its members are unambiguous when it comes to their objective. They merely record and reflect; we may draw whatever conclusions or make whatever judgments we like.

Coolidge once elaborated on the CLUI's mission by saying, "One of the functions of a regional program is to characterize the region by describing its built landscape, and in this way to offer a portrait of its economy, its culture, and its identity."[5] In order to portray the built environment as accurately as possible, the CLUI follows a rigorously unbiased method of data collection. Its process is truly inductive and uses sensible experience rather than assumption as its starting point. First, someone observes an interesting use of land, such as an expansive manufacturing complex or a human-made lake, and reports it to the CLUI. If it is deemed sufficiently unusual or exemplary, independent field researchers fill out forms to identify basic information about the site: what it is called, what it is used for, where it is located, and to what keywords it might relate.[6] A site-characterization form is typically accompanied by photographs that, although often taken by professional artists and photographers, remain anonymous documents produced by the CLUI. These images offer an "independent view and a primary level of site verification."[7] Eventually, a paragraph is written, based on the site-characterization form, to accompany the photograph and encapsulate "the form and function of the site."[8] Members of the CLUI regularly review these land use entries, and if the site is recognized as sufficiently instructive or important, it is entered into a set of publicly accessible files stored in their Culver City offices known as the Land Use Database.[9] The database serves as the foundation for the

5 Matthew Coolidge, Introduction, in *Overlook: Exploring the Internal Fringes of America with the Center for Land Use Interpretation* (New York: Metropolis Books, 2006), 25.

6 Ibid., 23–24.

7 Ibid., 22.

8 Ibid., 22.

9 Selections from the database are available at http://ludb.clui.org/.

CLUI's programming in that its exhibitions and tours are drawn from the entries contained in these files.

Coolidge once described the CLUI's role as "tripping over the protruding artifacts of the present on the way to explaining the extraordinary conditions we all find ourselves in all the time. As we stumble over the obvious, we ask ourselves, 'What is that thing anyway, and how did it get there?'"[10] This process of empirically based inquiry is remarkably scientific with one important exception — the Center for Land Use Interpretation does not approach its subject matter with a hypothesis. The scientific method asks researchers to define a question, gather information, form a hypothesis, collect data, analyze and interpret that data, and form a new hypothesis. Instead, the steps the members of the CLUI follow in their research share some remarkable characteristics with the method espoused by seventeenth-century philosopher Francis Bacon (1561–1626), who founded the scientific revolution in 1620 with his influential treatise *New Organon*.

An important predecessor to our current scientific method, Bacon's induction focused on the collection, comparison, and selective exclusion of factual observations in order to ascertain more general patterns and axioms. In his introduction to *New Organon*, he declared, "Our method, though difficult to practice, is easy to formulate. It is to establish degrees of

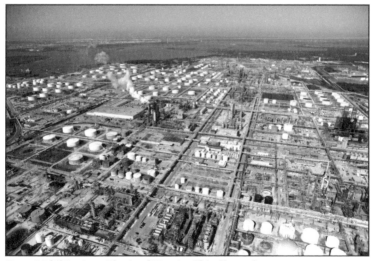

ExxonMobil Baytown Plant and Houston Ship Channel.

10 Coolidge, Introduction, 17.

certainty...to open and construct a new and certain road for the mind from the actual perceptions of the senses."[11] The text is also a diatribe against so-called scientists who base their research on commonly accepted assumptions rather than proofs based on sound observations. To this end, Bacon is careful to distinguish "anticipations" from "interpretations." According to him, "Anticipations are much more powerful in winning assent than interpretations; they are gathered from just a few instances, especially those which are common and familiar, which merely brush past the intellect and fill the imagination. Interpretations by contrast are gathered piece by piece from things which are quite various and widely scattered, and cannot suddenly strike the intellect. So that...they cannot help seeming hard and incongruous, almost like mysteries of faith."[12] Bacon, like the CLUI, insists that well-founded knowledge is the result of liberating the mind from false tendencies that distort the truth and cause us to pay attention only to what we see on a regular basis rather than experiencing and understanding evidence that might be farther afield. This is the essence of the "interpretation" in the CLUI's name, a commitment to accuracy in the search for truth.

The fundamental understanding that reality is based on the relationship between a first-person perspective and empirical evidence is recognized by the philosophical traditions of phenomenology and positivism as well as, and perhaps most significantly in the context of this essay, the history of conceptual art. In one of his first lectures on the University of Houston campus, Coolidge quoted an observation that Marcel Duchamp made when he spoke at the Convention of the American Federation of Arts in Houston, Texas, in 1957: "All in all, the creative act is not performed by the artist alone; the spectator brings the work in contact with the external world by deciphering and interpreting its inner qualification and thus adds his contribution to the creative act."[13] In referencing Duchamp and engaging in a quasi-scientific method, Coolidge hints that the CLUI's methodology bridges scientific and artistic traditions that regard the act of observation as the primary arena for an authentic experience and the determination of truth.

When it comes to conveying their studies, the emphasis is again on empiricism. From early on, the CLUI's publications and exhibitions brought

11 Francis Bacon, *Francis Bacon: The New Organon* (West Nyack, New York: Cambridge University Press, 2000), 28.

12 Ibid., 38.

13 Marcel Duchamp, "The Creative Act," in Robert Lebel, *Marcel Duchamp* (New York: Grove Press, 1959), 78.

people's attention to exemplary and unusual uses of land by simply recording them. A 1997 exhibition at Los Angeles Contemporary Exhibitions, *Hinterland: A Voyage into Exurban Southern California*, consisted of documentary photographs that, as Frank Gohlke or other New Topographics photographers might describe it, have a "passive frame." That is, "rather than the picture having been created by the frame, there is a sense of the frame having been laid on an existing scene without interpreting it very much."[14] The text that accompanies the photographs in CLUI publications

Sabine Promenade along Buffalo Bayou in downtown Houston.

often reads like an educational brochure from a chamber of commerce or natural history museum.[15] For example, the text on Plaster City says, "This plant at Plaster City is one of the largest gypsum plants in the country, and is owned by U.S. Gypsum, a company that manufactures more than half of the drywall in the United States. The source of the gypsum is the Fish Creek

14 William Jenkins, Introduction, in *New Topographics: Photographs of a Man-altered Landscape* (Carlisle, Massachusetts: Pentacle Press, 1975), 5.

15 The administrative aesthetic relates to the history of conceptual art; see Benjamin H. D. Buchloh, "Conceptual Art 1962–1969: From the Aesthetic of Administration to the Critique of Institutions," *October* 55 (Winter 1990): 105–143. For more on photoconceptualism, see Pamela M. Lee, "The Austerlitz Effect: Architecture, Time, Photoconceptualism," in Douglas Fogle, *The Last Picture Show: Artists Using Photography, 1960–1982* (Minneapolis: Walker Art Center, 2003), 185–194.

mine."[16] By offering only slivers of compartmentalized information in pictures and captions, the CLUI indicates that an understanding of the hinterland is more than the sum of its parts and pushes us to consider the big picture.

The CLUI's straightforward language in other instances has a tone that ranges from the humorous — such as the entry on Felicity, Center of the World, that reads "Though it could be said that the surface of a spherical planet could have an infinite number of 'centers,' this is the only Center of the World officially recognized as such by the Imperial County Board of Supervisors" — to the ominous — such as the entry on the 1928 San Francisquito Dam Failure Site, where 450 people were killed when the dam broke. The entry states that "William Mulholland,...[who] was responsible for the dam's design, inspected the dam twelve hours before the disaster and declared it safe. He retired soon after the accident and stated that he envied the dead."[17]

As they have done with many exhibitions that followed, the Center for Land Use Interpretation conducted bus tours of the sites highlighted in *Hinterland* during its run.[18] Coolidge compares the bus to a vitrine: "Bus tours...are like curatorial odysseys. Since you can't put the place/artifacts in a vitrine, you take the vitrine to them."[19] The practice of setting up a dialectic between an exhibition in a museum and the place that exhibition highlights harkens back to Robert Smithson and his concept of Site/Non-site. When author Jeffrey Kastner asked Coolidge about this dialectic at the heart of land art in 2005, Coolidge responded, "[For us] it's more of a trialectic — site, non-site, website — where you have this fluid electronic version of space that is a form of a non-site but is also something else. And increasingly, a lot of our efforts are being directed in mapping these sites into cartographic networks on the Web so that all this information — this multilayered portrait of America through its different land uses — can be explored in a scalable system where you can look for new relationships,

16 The Center for Land Use Interpretation, *Hinterland: A Voyage Into Exurban Southern California* (Triage Bindery, 2004), unpaginated.

17 Ibid.

18 The CLUI conducted three tours in 1997 related to the *Hinterland* exhibition; see Hooper, Coolidge, and Simons, "The Center for Land Use Interpretation Chronology," in *On the Banks of Bayou City: The Center for Land Use Interpretation in Houston* (Houston: Blaffer Gallery, 2009), 112.

19 Bree Edwards, interview with Matthew Coolidge, in *On the Banks of Bayou City: The Center for Land Use Interpretation in Houston* (Houston: Blaffer Gallery, 2009), 26.

juxtapositions, and contexts based on how and where you're looking."[20]

In 2001, the CLUI produced *Curious Orange: Points of View of the Landscape of Orange County*, an exhibition that consisted of a multiscreen projection of a map of the county with an interactive tracking ball. Points of interest were marked with orange dots, which when clicked allowed you to learn more about that site through text and photographs. Recent exhibitions have also included CLUI-produced videos. But even as the CLUI has expanded the range of its multimedia presentations, it has stuck with its basic aesthetic of induction, which focuses on strict documentation. Its presentations are only as dramatic and beautiful as the places themselves.

The CLUI's recent exhibition *Up River: Man-Made Points of Interest on the Hudson from Battery to Troy* consisted primarily of aerial shots of sites along the Hudson River from Ellis Island to the Federal Dam. Aerial photographs have a long history that predates the advent of the airplane, and in terms of tracking land use, they have been utilized for cartography as well as covert surveillance. Aside from these authoritarian points of view, perhaps the most common overhead views of the built landscape are those of suburban tract homes, which serve as a form of social critique. As cultural studies professor Holley Wlodarczyk has noted, "While young couples and growing families may have seen only the promise of their own individualized American dream-come-true in one of the seeming endless expanse of detached, single-family homes, the uniformity and scale of the view made possible by such images also practically illustrated aspects of such construction and consumption practices that architectural and social critics felt deserved their collective scorn."[21] But here again, the CLUI does not follow precedent. Its photographs of the Hudson do not emphasize homogeneity or waste, nor do they exemplify a certain power over that space. Instead, they show us what most people never see — private and industrial land use over time. For as Coolidge notes, "We are bound to forget what we choose not to see."[22]

20 Jeffrey Kastner, "True Beauty," *Artforum* (Summer 2005): 286–287. This interrelated triangle of experience includes the CLUI's extensive website, which contains a thorough collection of entries from its Land Use Database.

21 Holley Wlodarczyk, "Intermediate Landscapes: Constructing Suburbia in Postwar American Photography," in *Worlds Away: New Suburban Landscapes,* Andrew Blauvelt , ed. (Minneapolis: Walker Art Center, 2008), 102.

22 Matthew Coolidge, Preface, in *Up River: Man-Made Sites of Interest on the Hudson from the Battery to Troy* (New York: Blast Books, 2008), 5.

In this way, the CLUI has built on artistic traditions of photography, land art, and conceptual art, expanding them to new multimedia, web-based technologies and striking a delicate balance between an apolitical mission and the increasingly urgent need to understand land use. At the same time, a focus on the landscape recalls a very traditional definition of art as a rendering of nature, a view championed by nineteenth-century art critic John Ruskin, who once said, "You observe that I always say *interpretation*, never *imitation*. My reason for doing this is, first, that good art rarely imitates; it usually only describes or explains. But my second and chief reason is that good art always consists of two things: first, the observation of fact; secondly, the manifesting of human design and authority in the way that fact is told."[23] But the CLUI has expanded the concept of factual observation of landscape beyond what Ruskin envisioned to create a view of the landscape that adheres to unbiased empirical truth above all else.

The CLUI has used a quasi-scientific method of data collection, namely induction, to shatter subjectivity and cultivate a unique aesthetic experience. When one looks at a photograph, text, or web page from the CLUI, one sees only a limited and distinct piece of the overall picture. But one is drawn into a network of interpretations surrounding land use, while at the same time having enough space and autonomy to contemplate competing interests at a distance.

In the early 1950s, sculptor Tony Smith got the chance to drive down the New Jersey Turnpike while it was being built. He wrote in 1966 about the dark road lined by industry: "The road and much of the landscape was artificial, and yet it couldn't be called a work of art. On the other hand, it did something for me that art had never done The experience of the road was something mapped out but not socially recognized. I thought to myself, it ought to be pretty clear that's the end of art. Most painting looks pretty pictorial after that. There is no way you can frame it, you just have to experience it."[24] The cognitive dissonance inspired by unseen aspects of the built landscape is potent now more than ever. With an unprecedented amount of information available about our country, sometimes we forget that the vast majority of land in the United States is rarely seen by the public and, in the case of the military and industry, does not like to draw attention to itself. The only way to start to understand it is to notice it and experience it.

23 John Ruskin, *Selected Writings*, chosen and annotated by Kenneth Clark (London: Penguin Books, 1991), 149–150.

24 Samuel Wagstaff, Jr., "Talking to Tony Smith," *Artforum* (December 1966): 19.

As this book goes to press, certain details of *Texas Oil* are still being formulated. But I expect that this, like other CLUI exhibitions, will also challenge us to go out into the world, see the things that they have seen, and come away looking at our surroundings anew. Following members of the CLUI around Houston has profoundly changed the way I understand this city's role in the oil industry. It is one thing to hear that Houston is the energy capital of the United States and quite another to see giant tankers docked next to Glendale Cemetery, where the founders of the city are buried. I had always heard that many petrochemical products are made in Houston, but I had not experienced it until I stood in Manchester Park and smelled the sweet and smoky smell of the plant nearby and saw a sign that read "Danger: Acid Line." I do not fully comprehend these juxtapositions just yet. But the CLUI has inspired me to learn more. As Matt Coolidge said one day while talking to the UH creative writing students in the mobile office trailer, "All the CLUI wants to do is make the real world seem amazing, confusing, and astounding." The rest is up to us.

Rachel Hooper
Cynthia Woods Mitchell Curatorial Fellow
Blaffer Gallery, the Art Museum of the University of Houston

THE CENTER FOR LAND USE INTERPRETATION CHRONOLOGY

1994

The Center for Land Use Interpretation (CLUI) is founded in Oakland, California. The CLUI is a nonprofit educational research organization dedicated to the increase and diffusion of information about how the nation's lands are apportioned, utilized, and perceived.

The first issue of *The Lay of the Land,* the CLUI's newsletter, is published. *The Lay of the Land* contains site characterization reports, regional and thematic articles, book reviews, and detailed accounts of CLUI tours, exhibitions, and other activities. Thirty-one issues of the newsletter have been published to date.

The Land Use Database, an online computer database of unusual and exemplary sites throughout the United States, is launched. The Land Use Database is a free public resource designed to educate and inform the public about the function and form of the national landscape, a terrestrial system that has been altered to accommodate the complex demands of our society.

1995

Inspired by the Kodak Company's iconic "Picture Spot" tourist placards found in National Parks, the CLUI installs more than 100 "Suggested Photo Spot" signs next to photogenic sites across the country, including the tailings pile of a copper mine and the wastewater treatment facility of Kodak Company headquarters. A postcard and tour book, *Suggested Photo Spots: A Site Extrapolation Project of the Center of Land Use Interpretation,* is published by Hemingway Western Studies Center.

The CLUI publishing program is inaugurated with the booklet *5th Avenue Peninsula Tour,* a self-guided tour of Oakland's industrial waterfront. The CLUI publishing program continues to produce books, pamphlets, and catalogues drawn from the Land Use Database and CLUI exhibitions.

The CLUI begins to focus on the Model Earth program with *The Mississippi Model* exhibition, which features photographs of a two-hundred-acre model of the Mississippi River, one of three in the United States built by the

Army Corps of Engineers in the 1950s and '60s to study hydrology and flood control.

1996

The CLUI moves its headquarters from Oakland to Los Angeles.

The Nevada Test Site: A Guide to America's Nuclear Proving Ground, is published by the CLUI. It is the first book on the country's foremost weapons research and development test facility, the most bombed land where many underground and atmospheric tests of nuclear weapons were conducted, and one of the largest restricted areas in the United States. The CLUI later creates a CD-ROM with an interactive version of the guide that features clickable maps and more than 100 original photographs.

As part of the On-Site Exhibit Space program, a series of photographs is installed in an abandoned trailer on the edge of the Nevada Test Site, with the exhibition *Concentric Restrictions: Land Use Signage of the Nevada Test Site.*

The CLUI establishes a facility in Wendover, Utah, a town at the edge of the Great Salt Lake, situated on the border of Utah and Nevada. The CLUI opens the Wendover Exhibit Hall in a former military barracks in an abandoned WWII air base. The first exhibition is *Around Wendover: An Examination of the Anthropic Landscape through Maps and Photographs.* In 2005, the CLUI publishes *Points of Interest around the Old Wendover Airfield: An Inexhaustive Investigation of Current Context.*

The CLUI Field Unit, a mobile exhibition trailer with modular displays and printed material, travels to various sites in the southwestern United States.

On-site extrapolative projects continue, including the Sound-Emitting Device program of self-contained sonic signage. The Owens Lake sound-emitting device *Vasser Gheist* is installed in the middle of Owens Lake, California. The Event Marker sign project continues with the "Peculiar Detonation" series of descriptive signage, including the installation of a sign at the site where the historic plaque for the Shoal nuclear test was destroyed.

1997

Hinterland: A Voyage into Exurban Southern California, an exhibition that documents about 100 unusual and exemplary locations on the outskirts of Southern California, is displayed at Los Angeles Contemporary Exhibitions (LACE). The CLUI leads three bus tours: one north, *Antelope Valley: The Cradle of Aerospace*; one east of Los Angeles, *East Desert/San Bernardino County: The Desert Proper*; and one south, *The Salton Sea and Imperial Valley: The Land of Arid Water.* The CLUI also publishes a book to accompany the project.

The CLUI continues to develop research and display facilities in the town of Wendover. The Wendover Residency, an ongoing program that enables artists to live and work at the CLUI's exhibition and studio complex in Wendover and to interpret the local environment through their artwork, is supported with a grant from the National Endowment for the Arts. The Wendover Residency program also hosts annual programming by students from the Land Arts of the American West, the University of New Mexico, the University of Texas, and the California College of the Arts Curatorial Program.

1998

The Independent Interpreters program, in which individual artists and researchers whose work examines landscape and land use issues are invited to present their work to a CLUI audience, is inaugurated with a talk by Walter Cotten, who shows slides of his decades of photographic exploration of the internal fringes of the Southwest.

Government atomic testing films from the five declared nuclear nations—France, China, the former USSR, the UK, and the United States—are screened at the CLUI in Los Angeles. The CLUI also publishes the booklet *Nuclear Proving Grounds of the World.*

The exhibition *Model of Decay: The Chesapeake Bay Model,* which features photographs, films, and relics from a large-scale abandoned hydraulic model in Maryland, is mounted at the CLUI exhibition space in Los Angeles, and a companion book is also published, continuing the CLUI's Model Earth program focus.

The VORs of Texas, an exhibition of a typological photographic research project by Mark Curtin, is shown at the CLUI Los Angeles exhibition space.

These VOR (very high frequency omnidirectional range) antennas look like small isolated huts or lighthouses, but they broadcast coded pulses rather than emitting light. They are radio beacons, part of a nationwide network of navigational aids for aviation, and while their function is consistent, their shapes and coloration widely vary.

Subterranean Renovations: The Unique Architectural Spaces of Show Caves, is displayed at the CLUI exhibition space in Los Angeles. The show examines the architectural modification of American caves as underground tourist destinations, and includes photographs of the light show theaters at DeSoto and Meramec caverns, the lunchrooms at Carlsbad Caverns and Mammoth Cave, and the abandoned bandstand and dance floor deep within Wonderland Cave and Club in Bella Vista, Arkansas. A catalogue is published to accompany the exhibition, which is the first Under Land project studying land use beneath the surface of the earth.

1999

The vast landscape transformations of open-pit mining are revealed in *Monuments of Displacement: The Aerial Photographs of Bill DuBois,* an exhibition in the CLUI exhibition space in Los Angeles. The oblique aerial images show multicolored evaporation ponds, cascading layers of tailings piles, and huge stepped pits in the remote mountains of Nevada, the precious-metal mining capital of the country. DuBois presents a slide lecture on his images of open-pit mining and discusses the processes depicted.

Territory in Photo-Color: The Postcards of Merle Porter, by guest curator Sabrina Merlo, consists of twenty thousand Merle Porter postcards, on display and for sale at the CLUI Los Angeles exhibition space. Porter was a one-man postcard company, producing and distributing millions of cards over a fifty-year career. Nearly always about places, his works have a distinctive style, sometimes depicting famous sites but more often celebrating the ordinary landscape: highways, abandoned buildings, main streets, and oil fields.

An exhibition about Washington state, *100 Places in Washington,* is displayed at the Center on Contemporary Art in Seattle as part of the group exhibition *Land/Use/Action.* The CLUI conducts three daylong tours to Seattle sites featured in the show where the land has undergone several stages of uses and transformations, including the Hanford Nuclear

Reservation, possibly the most contaminated place on earth, and the industrialized Duwamish River. The CLUI also publishes a book on the chosen sites, *100 Places in Washington.*

Commonwealth of Technology: Extrapolations on the Contemporary Landscape of Massachusetts, an exhibition on the way technology has shaped the landscape of that state, is shown as part of the group exhibition *Landscape: Outside the Frame* at the MIT List Visual Arts Center. The project is also published as a book by the CLUI. An updated version is shown in 2008 as *Massachusetts Monuments: Images of Points of Interest in the Bay State* in the Mass MoCA group exhibition *Badlands: New Horizons in Landscape.*

The *Nellis Range Complex: Landscape of Conjecture,* an exhibition about the mysterious use of five thousand square miles of military-controlled land in Nevada, is shown at the CLUI exhibition space in Los Angeles. A two-day bus tour of the perimeter of the Nellis Range is conducted by the CLUI. As expected, permission was not received to enter into the Range at any point, making this a tour along the edges of an unvisitable place. A publication and an interactive CD-ROM on the Nellis Range are produced by the CLUI as part of its Isolate Zones program. Another version of the exhibition is shown at the Ibid Gallery through the Royal College of Art in London in 2003 as part of a curatorial exchange program.

2000

The CLUI expands its footprint in Los Angeles with larger galleries and bookshop, offices, a library, and a research room and archive that house the files of the Land Use Database.

The Desert Research Station (DRS), an abandoned educational facility in the Mojave Desert near Hinkley, California, is secured by the CLUI from the Bureau of Land Management, with the support of the Geffen Contemporary at the Museum of Contemporary Art in Los Angeles. The DRS provides CLUI programming for visitors, researchers, and school groups interested in studying the California desert. The CLUI Mobile Exhibit Unit, an exhibition trailer, is installed outside MoCA in downtown Los Angeles as part of the group exhibition *Flight Patterns* to display information about the DRS and the surrounding desert area. The CLUI conducts two public bus tours during the MoCA exhibition, both called *Lines of Flight: A Voyage*

along High Desert Vectors, which travel through many sites in the Southern California desert and include a stop at the DRS.

Continuing the study of the California desert region, the CLUI publishing program produces two books: *Points of Interest in the California Desert Region* and *Route 58: A Cross-Section of California.*

Formations of Erasure: Earthworks and Entropy, an exhibition consisting of contemporary photographs of land art, is shown at the CLUI exhibition space in Los Angeles. Many of these land art sites were constructed in the 1970s and have since have been taken over by the surrounding landscape. As part of the exhibition, Independent Interpreter Hikmet Loe, a Smithson scholar from Salt Lake City, presents unpublished material on the building of the *Spiral Jetty;* and Independent Interpreter Sam Durant, an artist and teacher at the California Institute of the Arts, gives a multimedia presentation about *Spiral Jetty*'s cultural context. *Formations of Erasure* is later shown at the Sonoma County Museum in 2003 and at the Princeton School of Architecture in 2004.

A CLUI exhibition *The Perceptual Arena of the American Landscape* is included in the group exhibition *Scripted Spaces* at Witte de With in Rotterdam, the Netherlands.

2001

On Locations: Places as Sets in the Landscape of Los Angeles is mounted at the CLUI exhibition space in Los Angeles. Images, text, and an interactive digital display show how places within the public realm can be transformed, physically and contextually, by the moving-image industries of film, television, and advertising.

Curious Orange: Points of View on the Landscape of Orange County, consists of four projections of satellite images of this notorious "post-suburban" county south of Los Angeles, with video of twenty featured sites that represent the infrastructure of the city. Visitors can navigate the projections using a trackball and choose sites to acquire more information via images, text, and video. *Curious Orange* is commissioned by the Beall Center for Art + Technology.

A yearlong examination of the San Francisco Bay area culminates in *Back to the Bay: An Exploration of the Margins of the San Francisco Bay Region,* an exhibition on display at the Yerba Buena Center for the Arts. Fifty sites

along the margins of the bay are highlighted with text and aerial photos, and further extrapolated during a series of public bus and boat tours and in a guidebook published by the CLUI. *Back to the Bay* is later included in the group exhibition *Out of True* at the University Art Museum of the University of California, Santa Barbara, and finally installed in the control tower building at the former Alameda Naval Air Station.

The CLUI hosts two Independent Interpreters in an analysis of the landscape of copper. Todd Trigsted, an information specialist for the Environmental Protection Agency, shows his work at the CLUI exhibition space in Los Angeles and talks about Butte, Montana, one of the most churned-up landscapes in the country and the nation's largest (or longest) Superfund site. Curtis Cravens, representing the downstream end of the landscape of copper, lectures at the CLUI about his exploration and documentation of the Laurel Hill Works, an abandoned (and now razed) copper and chemical complex in Queens, New York.

The CLUI is included in the group exhibition *Post-Landscape: Between Nature and Culture* at the Montgomery Art Center of the Pomona College Museum of Art.

2002

The barricades and security measures put in place after September 11 to surround and protect monuments, museums, government buildings, and other landmarks of Washington, D.C. is the subject of the exhibition *Proximity Issue: The Barricades of the Federal District,* shown at the CLUI exhibition space in Los Angeles.

Numerous sites of interest in Ohio are explored in the CLUI exhibition and publication *Points of Interest in Ohio: A Selection of Superlative Sites from the Center for Land Use Interpretation's Land Use Database.* The research is supported by the Contemporary Art Center (CAC) in Cincinnati, and a selection is included in the CAC's group exhibition and catalogue *Ecovention: Current Art to Transform Ecologies.*

The most "wired" building in the West, a telecommunications hub located in a seemingly ordinary office building in downtown Los Angeles, is the subject of *One Wilshire: Telco Hotel Central,* an exhibition of photographs and videos shown in the CLUI's Los Angeles gallery. This study is led by

urban historian Kazys Varnelis and is part of an ongoing exploration of infospace and the physical manifestations of the largely unseen digital communications infrastructure. The material is later included in the book *Blue Monday: Stories of Absurd Realities and Natural Philosophies,* edited by Richard Sumrell and Varnelis and published by Actar.

The CLUI initiates its Polar Studies program with *Antarctic 1: Views along Antarctica's First Highway,* on display in its Los Angeles exhibition space, and Independent Interpreter William L. Fox, a writer and researcher who specializes in the examination of cognition and perception in seemingly empty places. Fox provides material for the exhibition and gives a talk to a CLUI audience. *Antarctic 1: Views along Antarctica's First Highway,* is published as a CD-ROM with photographs and descriptions of the road as well as interactive aerial navigation of the McMurdo Base Station.

Ten CLUI photographs of the Inland Empire, a semi-urbanized, largely industrialized region east of the Los Angeles basin, are presented as part of the group exhibition *Alternate Routes* at the University of California Riverside/California Museum of Photography.

2003

The CLUI opens an office in Troy, New York, to serve as its Northeast field office and exhibition space.

The histories of individual lots of private and public land are the subject of *Property in the Harper Lake Basin,* displayed at the CLUI exhibition space in Los Angeles. The exhibition tracks patterns of development and decay in the Harper Lake Basin area—a dry lake bed in the Mojave Desert of California near the CLUI's Desert Research Station.

Independent Interpreter Sam Easterson gives a talk about his photographic work *Animal, Vegetable, Video.* The CLUI exhibition *On the Farm: Live Stock Footage by Livestock* reveals the point of view of farm animals outfitted with head-mounted wireless video cameras.

The Best Dead Mall in America: A Photographic Documentation of the Dixie Square Mall in Harvey, Illinois is shown at the CLUI's Los Angeles exhibition space. The electronic presentation, created by CLUI program manager Steve Rowell, portrays the entropy and organic reinvention of an eighty-thousand-square-foot mall that has been abandoned for more than twenty-three years.

Ken and Gabrielle Adelman's *California Coastal Records Project,* a sequential photographic portrait of the coast of California composed of more than eleven thousand aerial photographs, is featured in the CLUI exhibition space in Los Angeles. Shown as a digital projection with each image displayed for three seconds, each cycle of the program takes nearly ten hours to complete.

The CLUI expands its own archives of the West Coast of the United States in order to create a portrait of the liminal landscape for the group exhibition *Baja to Vancouver,* which travels to the Seattle Art Museum, the Museum of Contemporary Art San Diego, the Vancouver Art Gallery, and the CCA Wattis Institute of Contemporary Arts.

Using USDA soil maps of Los Angeles County as a point of departure, *Ground-Up: Photographs of the Ground in the Margins of Los Angeles* is shown at the CLUI exhibition space in Los Angeles, demonstrating how soil provides evidence of human interventions such as landfills, construction, and agriculture. A bus tour, *Margins in Our Midst: A Journey into Irwindale,* is conducted by the CLUI to Irwindale, a city near Los Angeles that has been quarried into deep pits for aggregates used to construct much of the infrastructure of the Los Angeles area. The tour later provides material for inclusion in the publication *The Infrastructural City: Networked Ecologies in Los Angeles,* edited by Kazys Varnelis and published by Actar. A version of the exhibition is later shown in the group show *Land Sakes Alive! Four Exhibition "Takes" on Southern California* at California State University Northridge Art Galleries.

2004

A View into the Pipe: East Central Interceptor Sewer is an exhibition that provides a glimpse into Los Angeles' main sewer pipe, located near the CLUI's Culver City office, as an installment in its Waste Stream program.

Loop Feedback Loop: The Big Picture of Traffic Control in Los Angeles, an exhibition on the physical and electronic infrastructure of the city's street system, is shown at the CLUI exhibition space in Los Angeles. As part of the show, Steve Rostam, an engineer from the City of Los Angeles' Automated Traffic Surveillance and Control Center (ATSAC), gives a talk at the CLUI Los Angeles space.

Diversions and Dislocations: California's Owens Valley, a group exhibition featuring the work of Aaron Forrest, Eva Castringus, David Maisel, and Andrew Freeman, is shown in the CLUI exhibition space in Los Angeles. As part of the show, the CLUI leads a two-day bus tour of the remote Owens Valley of eastern California, where 95 percent of the private land is owned by the City of Los Angeles. A book, *Points of Interest in the Owens River Valley*, is also published by the CLUI.

An exhibition on emergency and police training facilities in Southern California, *Emergency State: First Responder and Law Enforcement Training Architecture*, is shown in the CLUI exhibition space in Los Angeles. The artificial versions of ordinary places featured in the show are used in training exercises to enact mock hazardous material spills, train wrecks, building collapses, fires, and debris-strewn disasterscapes. The exhibition is later included in the group show *The California Files: Re-Viewing Side Effects of Cultural Memory* at the CCA Wattis Institute for Contemporary Arts in 2007.

The Tour of the Monuments of the Great American Void, a two-day CLUI-led bus tour to the *Spiral Jetty* and other sites around the Great Salt Lake, including an overnight stop in Wendover, is commissioned by the Museum of Contemporary Art in Los Angeles as part of the exhibition *Robert Smithson: Retrospective*. An updated version of the CLUI circumnavigation of the Great Salt Lake is later published by the Yale Architectural Journal in the book *Perspecta 41 Grand Tour* (MIT Press).

Vacation: Dauphin Island, images of dwellings built on stilts in a fragile coastal area, is exhibited at the CLUI Los Angeles, then at the Natural History Museum of Los Angeles County in 2007, and later that same year at the Boulder Museum of Contemporary Art as part of the group exhibition *Weather Report: Art and Climate Change*.

CLUI founding director Matthew Coolidge is awarded a Guggenheim Fellowship for New Media art.

2005

Immersed Remains: Towns Submerged in America, an exhibition about communities intentionally drowned—primarily flooded for the construction of reservoirs—is presented through photographs and video on display at the CLUI exhibition space in Los Angeles.

Independent Interpreter Jane Wolff, author of the book *Delta Primer,* presents her creative research on California's Central Valley to a CLUI audience. The California Delta is the largest estuary on the West Coast, a totally engineered landscape preserved by a precarious system of levees.

Terminal Island, an exhibition on an artificial landmass in the heart of the ports of Long Beach and Los Angeles, is shown at the CLUI Los Angeles space. Terminal Island is viewed as a sort of mythic, organic, flowing landscape machine. As part of the exhibition, the CLUI conducts a daylong tour of the port of Los Angeles by bus and boat.

The CLUI creates a display based on news clippings as part of *Old News* at Los Angeles Contemporary Exhibitions.

An interactive map of points of interest in the United States is created as part of a media arts fellowship with the Tribeca Film Institute.

2006

In recognition of the CLUI's work, founding director Matthew Coolidge is awarded the Lucelia Artist Award. The annual award given by the Smithsonian American Art Museum recognizes an artist under age fifty for his or her contribution to contemporary art.

Overlook: Exploring the Internal Fringes of America with the Center for Land Use Interpretation, an overview of the CLUI's projects and methodology, is published by Metropolis Books/DAP.

The CLUI sends an introductory touch screen kiosk that outlines its programming, designed by CLUI program manager Steve Rowell, to *Day for Night,* the Whitney Museum of American Art Biennial.

Thule, a remote U.S. Air Force station in Greenland where radar and telemetry systems monitor the skies as part of U.S. intelligence and missile defense, is the subject of *Ultima Thule: American Outpost at the Top of the World.* The exhibition is shown concurrently at the Greenland National Museum and Archives in Nuuk and at the CLUI exhibition space in Los Angeles.

Boron: The Element of Place, a daylong CLUI bus tour into the Mojave Desert, including a stop at the CLUI's Desert Research Station, is commissioned by *Afterall* magazine. A book on the region is also published, *Points of Interest in the Harper Lake Basin: A Mojave Microcosm.*

Dissipation and Disintegration: Antenna Sites and Debris Basins in the San Gabriel Mountains, an exploration of the infrastructure on the tops and bottoms of the mountains that ring Los Angeles by CLUI program manager Erik Knutzen, is shown at the CLUI exhibition space in Los Angeles.

The exhibition *Up River: Man-Made Sites of Interest on the Hudson from the Battery to Troy*, a collection of eighty-seven aerial photographs with accompanying text, debuts at the CLUI's exhibition space in Troy, New York. The catalogue is published by Blast Books in 2008, and the exhibition is shown at the PARC Foundation in New York later that same year. It then travels to other venues in New York state.

A portable slide lecture of the CLUI's study of the uses, purposes, and perception of the American landscape is included in *SPECIAL RECONNAISSANCE_*, a group show at Gigantic Art Space in New York City.

A selection of CLUI photographs is included in the group exhibition *Skirting the Line: Conceptual Drawing* at the Richard E. Peeler Art Center of DePauw University.

2007

Hinterland Redux: Things Changed and Not, in the Desert Proper, a CLUI-led daylong bus tour of California's Joshua Tree desert, is commissioned by the Museum of Contemporary Art in Los Angeles.

Pavement Paradise: American Parking Space, an exhibition about the liminal, substanceless, and static space of automotive transience, is shown at the CLUI in Los Angeles, and a catalogue is published by the CLUI.

A photo-documentary research project on the building materials used to construct the Broad Contemporary Art Museum (BCAM) is commissioned by the Los Angeles Museum of Contemporary Art for its publication *BCAM/LACMA/2008*.

Fifteen CLUI posters of the group's exhibitions, tours, and programs are included in *Celebrating the Lucelia Artist Award, 2001–2006*, at the Smithsonian American Art Museum in Washington, D.C. These posters are later included in the iCI (Independent Curators International) group show *Experimental Geography*, which will tour the United States from 2008 to 2010.

Independent Interpreter Heather Rogers, author of *Gone Tomorrow: The Hidden Life of Garbage,* gives a presentation to a CLUI audience as part of its Waste Stream program.

The Blue Ridge Parkway: America's Drive-through National Park, an exhibition about a trans-state recreational carscape in the Blue Ridge mountains, is shown at the CLUI exhibition space in Los Angeles.

CLUI publications are included in "the backroom" at La Celda Contemporánea Gallery at the University Claustro de Sor Juana in Mexico City as a satellite project to the *Otra de Vaqueros* in Mexico City.

2008

The fragmented, dendritic end of the Mississippi River at the Gulf of Mexico, which from the air resembles a bird's foot, is the subject of the exhibition and CLUI publication *Birdfoot: Where America's River Dissolves into the Sea,* a 35-minute photoscape presentation at the CLUI gallery in Los Angeles.

Autotechnogeoglyphics: Vehicular Test Tracks in America, aerial images of automotive test tracks, is included in the exhibition *Worlds Away: New Suburban Landscapes* at the Walker Art Center in Minneapolis, and is also shown at Between Bridges in London.

The waste stream of Los Angeles, from curbside bins to landfills and beyond, is examined in the exhibition *Post Consumed: The Landscape of Waste in Los Angeles.* As part of this program, the CLUI conducts a bus tour of the largest active landfill in the nation in Puente Hills, California. The CLUI show is later included in *Into the Open: Positioning Practice* as part of the U.S. Pavilion at the Venice Architecture Biennale.

The CLUI establishes a field office on the banks of Buffalo Bayou in Houston, Texas, with the support of a University of Houston Cynthia Woods Mitchell Center for the Arts residency. The residency culminates in the exhibition *Texas Oil: Landscape of an Industry* at Blaffer Gallery, the Art Museum of the University of Houston.

Compiled and edited by Rachel Hooper, Sarah Simons, and Matthew Coolidge

SELECTED BIBLIOGRAPHY OF EXTERNAL LITERATURE

MONOGRAPHS AND ONE-PERSON EXHIBITION CATALOGUES

Center for Land Use Interpretation, The. *Up River: Man-Made Sites of Interest on the Hudson from the Battery to Troy.* New York: Blast Books, 2008.

Coolidge, Matthew, and Sarah Simons, eds. *Overlook: Exploring the Internal Fringes of America with the Center for Land Use Interpretation.* New York: Metropolis Books, 2006.

GENERAL LITERATURE AND GROUP CATALOGUES

Andrews, Max. "The Center for Land Use Interpretation," in *2006 Whitney Biennial: Day for Night.* exh. cat. Chrissie Iles and Philippe Vergne, eds. New York: Whitney Museum of American Art, 2006.

Butler, Cornelia H. "A Lurid Presence: Smithson's Legacy in Post-Studio Art," in *Robert Smithson*, Eugenie Tsai, ed. Berkeley: University of California Press, and Los Angeles: The Museum of Contemporary Art, 2004.

_____. "document and intervention," in *Flight Patterns*, essays by Cornelia H. Butler, Lee Weng Choy, and Francis Pound. Ostfildern, Germany: Cantz, 2000.

Center for Land Use Interpretation, The. "Autotechnogeoglyphics: Vehicular Test Tracks in America, 2006–2007," in *Worlds Away: New Suburban Landscapes*, Andrew Blauvelt, ed. Minneapolis: Walker Art Center, 2008.

"Center for Land Use Interpretation: Interview with Matthew Coolidge, Director," in *Badlands: New Horizons in Landscape*, Denise Markonish, ed. North Adams: Mass MoCA, 2008.

Coolidge, Matthew. "The Fifty-Eight States of California," in *After the Gold Rush*, by Jeremy Deller. San Francisco: CCAC Wattis Institute for Contemporary Arts, 2002.

_____. "Points of Interest on the West Coast of the Continental United States from the Center for Land Use Interpretation Database" in *Baja to Vancouver: The West Coast and Contemporary Art*, Ralph Rugoff, ed. San Francisco: CCA Wattis Institute, 2003.

Coolidge, Matthew, and Erik Knutzen. "A Guided Tour of the Center for Land Use Interpretation," in *Recent Pasts: Art in Southern California from the 90s to Now*, Vol. 1, SoCCAS Symposia, John C. Welchman, ed. Zurich: JRP/Ringier, 2005.

Fox, William L. *Playa Works: The Myth of the Empty.* Reno: University of Nevada Press, 2002.

Lippard, Lucy R. "Parking Places," in *On the Beaten Track: Tourism, Art, and Place*. New York: The New Press, 1999.

_____. "Weather Report: Expecting the Unexpected," in *Weather Report: Art and Climate Change*, essays by Lucy R. Lippard, Stephanie Smith, and Andrew C. Revkin. Boulder: Boulder Museum of Contemporary Art, 2007.

Markonish, Denise. "Manifest Destiny to Global Warming: A Pre-Apocalyptic View of the Landscape," in *Badlands: New Horizons in Landscape*. North Adams: Mass MoCA, 2008.

Spaid, Sue. "activism to publicize ecological issues/monitoring ecological problems," in *Ecovention: Current Art to Transform Ecologies*. Cincinnati: The Contemporary Art Center, 2002.

_____. "The Center for Land Use Interpretation," in *The Broad Contemporary Art Museum at the Los Angeles County Museum of Art 2008*. Los Angeles: Los Angeles County Museum of Art, 2008.

PERIODICALS, NEWSPAPERS, THESES, AND INTERNET SOURCES

Balaschak, Chris. "Vacation: Dauphin Island." *Frieze* 99 (May 2006): 174.

Bacall, Analisa Coats. "Suggested Thinking Spots: On *Suggested Photo Spots* and the Center for Land Use Interpretation." Master's thesis, University of Utah, 2008.

Barden, Lane. "*Model of Decay* at the Center for Land Use Interpretation." *Artweek* 29, no. 7 (July/August 1998): 29.

Bernhard, Brendan. "Play of the Land: The Center for Land Use Interpretation— Where Art, the Internet, and Ten Guerilla Geomorphologists Collide." *LA Weekly* 19, no. 27 (May 30–June 5, 1997): 22–27.

Berwick, Carly. "Voyeurschism." *artbyte* (March/April 2001): 42–51.

Byrd, Anne. "Up River: Points of Interest on the Hudson from the Battery to Troy." *The Brooklyn Rail*, October 2007, http://www.brooklynrail.org/2007/10/artseen/up-river, accessed August 2008.

Capps, Kriston. "The Lucelia Artist Award: Matthew Coolidge of the Center for Land Use Interpretation." *Eye Level, the Blog of the Smithsonian American Art Museum*, April 27, 2006, http://eyelevel.si.edu/2006/04/the_lucelia_art.html, accessed August 2008.

Center for Land Use Interpretation, The. "The American Land Museum at Wendover, Utah." *Cabinet* 10 (Spring 2003): 77–80.

Chamberlain, Colby. "Center for Land Use Interpretation." Artforum.com, May 21, 2008, http://artforum.com/archive/id=20218, accessed August 2008.

Cotter, Holland. "Collectives Blurring the Lines of Who Makes Modern Art." *The International Herald Tribune*, March 8, 2006, 22.

_____. "Doing Their Own Thing, Making Art Together." *New York Times*, January 19, 2003, sec. 2, 1.

Currey, Mason. "This Land Is Your Land: The Center for Land Use Interpretation Surveys the American Terrain." *Metropolis* (September 2006): 38.

"Defining Landscapes." *High Performance* (Fall 1996): 5.

Dillon, Brian. "(Sub) Terranean Kitsch." *Art Review* (London) 6, (December 2006): 116–119.

Edwards, Bree. "Immersion in the Land of Oil." *Artlies* 58 (Summer 2008): 60–65.

Emery, Mike. "Students Explore Houston with Guidance from Los Angeles–Based Center for Land Use Interpretation." *University of Houston Campus News* 12, no. 6 (April 2008): 3.

_____. "UH Students Explore Houston with Guidance from Center for Land Use Interpretation." *University of Houston CLASS graffit-e*, July 2008, http://www.class.uh.edu/enews/2008/07/index.html, accessed August 2008.

Feeney, Mark. "Putting Interpretation to Good Use: Photo exhibit looks at how land is utilized from different perspectives." *Boston Globe*, March 9, 2008, sec. N,6.

Harvey, Doug. "Terminal Viscosity." *LA Weekly*, May 27, 2005, 62.

Haug, Kate L. "The Human/Land Dialectic: Anthropic Landscapes of the Center for Land Use Interpretation." *Afterimage* 25, no. 2 (September/October 1997): 3–5.

Herman, Daniel. "Lords of the Muddled Earth." *Artforum* (January 2004): 39–40.

Holte, Michael Ned. "The Administrative Sublime or The Center for Land Use Interpretation at the Circumference." *Afterall* 13 (Spring/Summer 2006): 18–26.

Iannaccone, Carmine. "Robert Smithson and Gianfranco Gorgoni at ACE; *Formations of Erasure* at the Center for Land Use Interpretation." *Art Issues* 65 (November/December 2000): 54.

Johnson, Reed. "The World Is Their Canvas; 'Artists in the Non-Art World' Try to Reshape the Way We Think about Man-Made Topography." *Los Angeles Times*, August 6, 2002, E1.

Kanouse, Sarah. "Touring the Archive, Archiving the Tour: Image, Text, and Experience with the Center for Land Use Interpretation." *Art Journal* 64, no. 2 (Summer 2005): 78–87.

Kastner, Jeffrey. "True Beauty: Jeffrey Kastner Talks with Matthew Coolidge about the Center for Land Use Interpretation." *Artforum* (Summer 2005): 286–287.

LaBelle, Charles. "Puzzlin' Evidence." *Frieze* 57 (March 2001): 86–87.

Lange, Christy. "Walking the Land." *Afterall* 13 (Spring/Summer 2006): 10–17.

Lee, Pamela M. "My Enemy/My Friend." *Grey Room* 24 (Summer 2006): 100–109.

Manaugh, Geoff. "Los Angeles, California." *Dwell* (May 2008): 196–210.

McArthur, Roshan. "Property Scouting: The Center for Land Use Interpretation." Been-Seen.com, January 2, 2008, http://been-seen.com/article.cfm?id=10508, accessed August 2008.

Ortega, Francisca. "Dynamic Disciplines; Local Universities Bridge Academic Fields to Address Sustainability." *Houston Chronicle*, April 20, 2008, sec. Living Green, 6.

Pagel, David. "A Little Social Spelunking." *Los Angeles Times*, October 9, 1998, sec. F, 25.

_____. "Desert Scenes: Industry, Oddballs, and Zzyzyx." *Los Angeles Times*, June 6, 1997, sec. F, 15.

Reynolds, Christopher. "A New Winner on the Landscape." *Los Angeles Times*, April 30, 2008, sec. E, 38.

_____. "Portraits of Man vs. Land." *Los Angeles Times*, January 21, 2007, sec. F, 4.

Smith, Roberta. "Center for Land Use Interpretation—*Formations of Erasure: Earthworks and Entropy*." *New York Times*, May 25, 2001, sec. E2, 29.

Spaid, Sue. "Center for Land Use Interpretation—Hinterland: A Voyage into Southern California Exurban Activity." *Art Papers* 22 (January/February 1998): 37.

Stone, Melinda. "Landscape of Conjecture: View from the Center for Land Use Interpretation." *Public Art Review* 10, no. 2 (Spring/Summer 1999): 30–32.

Strausbaugh, John. "Take Nature, Add Humans, Observe Results." *New York Times*, September 24, 2006, sec. 2, 30.

_____. "The Hudson's New Wave." *New York Times*, August 1, 2008, sec. E, 25.

Swartley, Ariel. "Wonders of the Wasteland." *Los Angeles Magazine* 47, no. 12 (December 2002): 64–69.

Trainor, James. "This Land Is Your Land." *Frieze* 88 (January/February 2005): 94–97.

transparadiso (Barbara Holub and Paul Rajakovics). "The Center for Land Use Interpretation, 9331 Venice Boulevard, Culver City." *Arcade* 23, no. 2 (2004): 36–37.

Ullrich, Polly. "Simparch's Social Sculpture at the Wendover Air Force Base." *Sculpture* 23, no. 4 (May 2004): 24–25.

Wertheim, Margaret. "Flow, Baby, Flow." *LA Weekly*, March 19, 2004, 36.

Zancan, Roberto. "CLUI. Un Museo del Territorio." *Domus* 908 (November 2007): 97–100.

PHOTOGRAPHY CREDITS

CLUI Photographic Archive: cover, frontispiece, 8-22, 28, 33, 52, 84, 88, 93–94, 98–105

Jeff Balke: 25

Rachel Hooper: 42, 45, 86, 91

SIMPARCH: 40-41

Sylvia Sykula: 31, 34

Katherine Veneman: 26, 49, 65, 88

Geoff Winningham: 69 (panorama), 71 (panorama)

zero—Buffalo Bayou Studio: 47, 73 (panorama), 75 (panorama)

Recycled
Supporting responsible use
of forest resources
www.fsc.org Cert no. SW-COC-002888
© 1996 Forest Stewardship Council

FSC

THE FSC TRADEMARK IDENTIFIES PRODUCTS WHICH ARE MADE FROM WOOD FROM WELL-MANAGED
FORESTS CERTIFIED IN ACCORDANCE WITH THE RULES OF THE FOREST STEWARDSHIP COUNCIL